# CONTEMPORARY
# MEXICAN ARTISTS

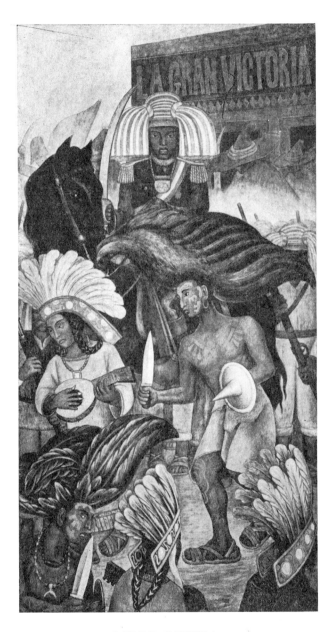

**DIEGO RIVERA**
Carnival in Huexotzingo (Fresco, 1936), Hotel Reforma, Mexico City

# CONTEMPORARY

# MEXICAN

# ARTISTS

AGUSTIN VELAZQUEZ CHAVEZ

*Essay Index Reprint Series*

BOOKS FOR LIBRARIES PRESS
FREEPORT, NEW YORK

First Published 1937

Reprinted 1969

ND 255
V 38

STANDARD BOOK NUMBER:

8369-1159-8

LIBRARY OF CONGRESS CATALOG CARD NUMBER:

77-88034

PRINTED IN THE UNITED STATES OF AMERICA

TO

ANTONIO CASTRO LEAL

"Art, as it is what it is and does what it does, is a form or mode, and only one among others, of spiritual being or power or functioning. An active or energetic knowing. The beholding of what is individual, that and nothing less or more or other, that always and that everywhere."

# FOREWORD

THE present volume is not a record of all modern Mexican artists. Fully aware of the limitations that must inevitably accompany a book of this kind, my only aim has been to convey a general idea of Mexican painting of our time, and to introduce the reader to the most representative exponents of contemporary Mexican art.

I have tried to include all artists — men born around 1880 — who were responsible for the beginning of, and in a certain sense gave orientation to, our present art movement, as well as the younger artists who have contributed to its more recent development. José Guadalupe Posada, whose work was a forerunner of contemporary social painting in Mexico, is the only exception in this scheme.

Foreign painters who have worked among us temporarily, such as Jean Charlot and Tamiji Kitagawa, are not included; nor are included other painters born in the country, but whose most interesting work has been done outside. In both cases the artists' work has been disconnected from the reality, needs, conflicts and aims of our art movement. The Guatemalan, Carlos Mérida, has been included because the most important part of his work has been accomplished during the evolution of our present artistic period.

The publication is intended neither as a history nor as a critique of contemporary Mexican painting. Such a history — dealing with a cultural expression whose significance in Mexico is comparable only to that of pre-Cortesian sculpture, colonial architecture, and the lyric poetry of the past fifty years — cannot be written when the subject matter is not yet two decades old. On the other hand, a critique could not escape the passions and limitations to be found in present day art. However, I have considered it necessary to supply the reader with an extremely brief outline of

the period during which the Mexican cultural movement, a resu of the Revolution of 1910, first gave birth to what has come t be contemporary Mexican art.

The purpose of the notes scattered through the book has bee to supply the reader with indispensable biographical informatior as well as with a very brief appraisal of the work of each artist.

The selection of illustrations has been carried out in suc manner that, wherever possible, no previously published or alread well known works have been included. The choice of the illustra tions has been dictated by my aim to present a more or less clear pic ture of the variety, richness of theme, subject matter, motives an original aspects of contemporary Mexican painting. The obser vant reader will discover the traits which characterize each artist' work, and in some cases, examples of the various technical mean which he has employed.

The present volume, the first of its kind ever published in thi country, has been furnished with an extensive and selected bibli ography, in the hope that it may serve to initiate broader and mor detailed investigations not only of present day Mexican art i general, but of the work of every artist mentioned in these pages

I wish to thank Mrs. Carolina Amor de Fournier, and Mis Inés Amor from the Mexican Art Gallery; Mrs. Alma Reed Director of Delphic Studios; Mr. Alberto Misrachi from th Central Art Gallery; Mr. Carl Zigrosser from the Weyhe Gallery and Mr. Francisco Sergio Iturbe, for their generous cooperation ir this work and their permission to reproduce some of the work appearing within these pages; and Miss Liza Kraitz, for he generous interest and valuable assistance in the revision and proof reading of the English text.

A. V. C.

New York City, December, 1936.

# CONTENTS

# ILLUSTRATIONS

## José Guadalupe Posada

## Fermín Revueltas

## Diego Rivera

## Manuel Rodríguez Lozano

[xv]

# THE BIRTH OF
# CONTEMPORARY
# MEXICAN ART

# THE BIRTH OF
# CONTEMPORARY MEXICAN ART

## The Antecedents

THE primitive pictorial art of the old Anáhuac civilizations, like the cultures of the Orient, Egypt and Greece, had two purposes. It was used to conserve the memory of various happenings, myths and religious beliefs, and to satisfy the pictorial needs of the peoples. The products of this primitive art, therefore, were to be found in public life in the codex kept by the priest, or on pyramids, temples, military constructions or markets, in the form of hieroglyphics on skins, stuccos, frescoes and mosaics; and in private life in the objects of the domestic cult, vases, carpets and clothes, in patterns or designs that possessed sometimes an anecdotal, sometimes merely a decorative, significance.

The absence of realism, together with broad techniques and sublime, comprehensive form, gave it mystery and majesty. Its figures and designs were a medium and a language through which the Indian spirit expressed its ideas and beliefs. Its practice was a political cult, confided to the vigilance of the theocratic power which secretly preserved its rules and techniques. The biological evolution of the race which produced it, the social-economic organization in which it existed, conferred upon it a collective function, consistent with its ends. It flourished and prospered in the places where pre-Hispanic cultures appeared and died.

When the Spaniard arrived at Anáhuac, he found a culture at which he marveled. It denied, and was antagonistic to, the thoughts and religious forms of the Christian myth, but it had forged a complex social state, in which painting was not unknown. The Franciscan missionary soon began the spiritual conquest of

the towns which the soldier had overcome physically. Substituting altars for idols, he insured victory. Christian temples were erected — material and spiritual fortresses of the power of the conquerors: chapels and churches, built upon the Indian *teocalis*. The pictures and statues which represented the new gods and myths opened the way to the plastic arts.

Once the first Christian school was founded, instruction in the art brought by the missionary was initiated. The high clergy observed with satisfaction the earnestness of the Indian in painting and sculpturing, especially since he ignored the Christian language and writing. In the arts, therefore, material needs and political purposes became identified.

Idolatrous religion was extinguished, the pagan priest with it; and the primitive pictorial resources also died. The technique found by the missionary was relegated to oblivion. The hieroglyphics, which the Spaniard found "lacking in beauty and grace and in the science of chiaroscuro and perspective," he replaced with copies of the statues and pictures he had brought from Spain, showing the fresh influence of Arabian art.

The construction and the ornamental motifs, the painting and sculpture of that age, were characterized by laxity of drawing, monotony of tone, naivety of form, simple spacial definitions — evidence of the savage depths of the fighting Spaniard and the primitive nature of the Indian and Arabian spirits, united in an art full of ecstasy, piety and suffering. The new subjugation, its tragic and melancholy lamentations, found an echo in the pictorial representation of Christ's martyrdom—as they did in the nostalgic desolation of the Arabian melody which the missionary compelled the Indian to chant after sowing.

Times passes; the Conquest broadens. More provinces are added to the kingdom of New Spain. The artistic work of domination is achieved by the missionary and Indian guide together. The

political power of the Spanish government is built up in the cities; that of the church, in the convents and sanctuaries of the country. Soldiers, merchants and noblemen come from overseas. The friar and the Indian live in the villages. Prayer surges from the fountain of the convent, the sanctuary or the chapel. The peasants go there with tribute and gifts for the Mass which reveal the pictorial adornments of their life. The priest observes the ability, the phantasy, the creative power of the Indian peasant, and decides to convert him into an artisan. A need for shops arises, and the crafts spring up among the Indian congregations near the convents and sanctuaries which tax, teach, control. The church presents to the Crown material evidence of the economic and spiritual domination of the vanquished peoples.

The exploitation of the mines, *haciendas,* or great *latifundiums,* is taken up by the military and political power of New Spain. These agents have no other arms than the whip and the torment, which shorten, cripple or destroy human existence. Cities grow through the extraction of minerals and the trading of seeds. The wealth thus produced initiates exportation and importation. The wants of the cities are paid for in silver and corn.

And an enormous economic and social division is established in the life of New Spain, a division which will grow in intensity with time, up to the Mexico of the nineteenth century. This is carried over into the domain of culture. Two arts emerge: that of the city and that of the fields: one, European; the other, the product of the Indian and the colonial Spaniard of the sixteenth century.

During colonial times the painting of the city is a reflection and a direct result of the wealth and the power of Spain in the Old Continent. In the first century of independent life the city is to offer isolated pictorial manifestations which do not escape the influences and models of the great European cities.

[21]

# The Painting of the City

THE painting of the city develops chiefly in the city of Mexico, in Puebla de los Angeles, and to some extent in the city of Guadalajara. The first was the center of the political activity of the government; the second was a very immediate participant, owing to its proximity to the capital. The *"Perla del Bajio"* was a very important commercial and theological center of New Andalusia.

The painting of the city was of the religious variety, representing Catholic themes dictated by the high clergy, sometimes assigned in special treatises. The artist worked for nearby churches and convents, and occasionally for the homes of noblemen and rich merchants. His product, which had scarcely any influence on the cultural development of the inhabitants of the cities, created the so-called "School of Colonial Mexican Painting." In sculpture it had very few repercussions, and in the graphic arts even fewer. To a great extent, paper, printing ink, types and engravings were imported from Spain; and their distribution and use were sternly supervised by the Inquisition and the government.

Two centuries were filled with the work of more than one hundred and fifty painters who paid little attention to portraiture. Nor did the landscape of the country, rich and varied with the luxury of the tropics, excite the imagination of these artists, who disregarded surrounding reality and nature. The influence of European masters was transferred through disciples of Velázquez, Murillo and Ribera who passed through the colony. Occasionally works by Spanish, Flemish or Italian masters were imported into Mexico.

It was the churches, convents, colleges and doctrinal community establishments which gave the artist needed employment. Art flourished and prospered in this field because it had a motif, a

definite destination, a political end to fulfill, a collective function to develop — and a market in which it found remuneration.

It left chiefly canvases — some very large — serving as decorations and ornaments in cathedrals and churches, which they beautify and enrich. There are a few examples of fresco and tempera murals. This art was "cloistered," succeeding without interruption from master to disciple. Often these men were members of a sect, order or religious community with traditions and purposes which took no account of the Indian peasant or the halfbreed who lived on the ranches, in the mountains and small villages, geographically isolated, exploited and oppressed. The cultural interests of the two groups could not possibly be related.

The creole, descendant of the first conquerors, lived in the colony from his birth. He inherited the wealth of the mines and *haciendas* which his parents had discovered and developed. He was arrogant, intrepid and unruly, like his adventurous grandfather. Avarice was necessary to his existence; the maintenance of his wealth depended on it. The Spanish Crown, a majestic entity many miles distant, a vigilant master, supervisor and judge, levied on him continually an economic burden. The church, while it gagged his conscience, continually menaced him with the Inquisition. His position carried weighty disadvantages.

When the creole went to Spain he fared little better. Here he was no longer a Spaniard. If a title of nobility protected and identified him, he was called *Americano;* if not, he was called *Indiano.* In the Spanish court he discovered that the world into which he had been born supported luxuries hitherto denied to him. In view of these things his glances went back to the lands of America, which now seemed to offer prospects of greater power and arrogance.

Again racial heritage emerges. The creole, conscious of himself as a "Spanish American," ambitious to establish and show off the

greatness of his class, enlarges the cities. He begins to concern himself with politics. He recognizes in the *mestizo* an element through which, by virtue of its racial proximity to both castes, he may dominate the Indian groups of the country. He preoccupies himself with laws that do not emanate from Spain, and takes advantage of the opportunities which his wealth gives him to take over politics when the Spanish government weakens. He endorses the formation of the *mestizo* or Indian clergy, and en-dorses the establishment of religious colleges for Indians and *mestizos,* but he weakens the church economically. He cooperates in the expulsion of the most intelligent and political of religious orders. He tries to throw the missionaries out of the villages. He supports the new expeditions that the friars make to the provinces of Upper California and Texas, separated from the center of the colony by thousands of miles of arid desert. He obtains posts in the army and in the government. He begins to revive industry and com-merce which the Inquisition has secluded within the convent. He obtains concessions in private trade, and in the collection of duties, revenues and taxes. He initiates the business of exportation to the Orient and to Florida, and to a lesser degree he trades with English merchants. He brings the spirits which have fomented art in the cities into the first political struggles. And with all this he lays the foundation for an emancipation which will grow to greater pro-portions than he desires.

The end of the eighteenth century finds the painting of the city at its height. Artistic effort exceeds the limits of material possibilities, for art still remains in the hands of the Church, its market flooded. But at length the expense of supporting artistic endeavor compels the church to lease this function to the govern-ment, which in turn secludes it in the Academy of San Carlos. This academy has been founded for the purpose. It is the sepulchre which the first half of the nineteenth century offers to painting

Its statutes give it a monopoly of teaching. They prohibit admittance or instruction to the Christian of Indian origin. Anyone violating the oath of admittance is threatened with expulsion. The road that art takes in the academy breaks the pictorial tradition. Eventually the lack of a secular market again stops production. The painter in the first half of the century has no job. The wealthy houses are busy with wars of independence. Revolts are continuous. The creole and the *mestizo* of the cities have little money or time even to fight their enemies: Spain, the church and the insurgents., This is a period culturally destitute.

Little by little, however, the country begins to define its political structure. The liberal governments have on their side elements that are concerned with art. In 1860, Bernard Couto calls the attention of the people to the subject. He talks of its importance. He wants to give the artist occupation; he wants to find a setting for it. He writes: "Perhaps a kind of painting—the mural — could still be employed; its use must be introduced in the decorations of public buildings." Couto reorganizes the Academy of Fine Arts. In his desire to "give art a destination in the future," he makes the pupils paint frescoes for the building. But art must have human material: ideas, purposes, desires. Couto's intentions do not go beyond the limits of the academy walls.

The painting of the city in the later years of the nineteenth century finds neither tradition nor purpose. Its only interests and preoccupations are with form. In a few fortunate instances the currents and modes, the styles of the European masters which sporadically reach Mexico, provide some inspiration.

In the academy or in the master's study the painter acquires a scholarly background. After local successes in semi-professional circles, the government pensions him and he goes to Spain, France, Italy. If he is one of the more talented, he returns to America

with greater knowledge and improved technique; but vigor and individuality have been lost in the imitation of European models. Any slight rebellion of the spirit, any search for new horizons, is confounded in the romanticism and in the expressionism of French painting of the end of the century or in the currents of Böcklin and Klinger.

The investigation of Mexican elements reaches no further than to horrible copies or applications of the ornamental elements of ancient Aztec art, or, in the most interesting cases, to scenes painted as a bad French or Italian painter might paint them. The figures are artificial, incongruous, false of inspiration. In the artist there is no cultural pre-occupation with the milieu in which he lives, nor is there any dramatic conflict to express. Without a political end to attain or a collective function to develop, without a market for his product either in his own country or in foreign lands, his pictorial expression is subject to academic rule, to the example which his ignorance calls "classic."

Neither the European master nor the painter of foreign-school models could know or understand the essential realities of the Mexican people. The Mexican painter of 1910 was an isolated element — a stranger to the true stream of Mexican culture.

# The Painting of the Fields

IN the country, in the Indian towns, in the small provincial cities with the aesthetic and social characteristics of the pre-Cortesian civilization — subject to the influence of the Spanish missionary and the uses to which he put this art — there lives another pictorial expression. Chinese and Japanese models, introduced through the oriental trade of the Pacific Coast, have also left their mark upon it.

The sentiments of this expression, when it appeared in objects of popular use, or emerged in low quarters in decorations for mills, workshops and *pulque* shops, the city long ignored and despised. It looked upon this art with indifference, unable to discover its real nature and appreciate its depth.

The art of the fields is no abstract concept. It is born of the necessities of life, to satisfy social demands. The design, the color, is applied to cloths, and to the dresses that the peasants wear. It exists in the objects of the domestic cult, in toys, and in tools for home use. It gives such artistic enjoyment as the people require and political interests permit. In the carnivals, the fiestas and markets, it affords amusement as well as decoration. It is singularly free of artistic convention. It does not aspire to luxury or greatness. Yet this art is profoundly creative, for it is interwoven with the familiar life of the people.

The Indian artist who creates it divides his time between the cultivation of the fields and the labor in his workshop. He knows toil and oppression. The passions of his art are the passions of the slave: prayer and vengeance and the struggle for justice. At the same time we find the sentiments of the simple countryman face to face with nature, a naive preoccupation with decoration for its own sake, and an engaging phantasy.

Religious themes are drawn from the liturgy and the Catholic myth, but in the main the Indian artist is occupied with the life

[27]

around him. They reveal mysticism and superstition and his lack of positive knowledge of the true nature of his surroundings. The world as it appears to him is full of conflicts, and the incidents of his life, the sheer fact that he lives, are sources of astonishment. Wonderful contradictory occurrences in which he feels that the divine miracle is unveiled, transform his material and create the subjects of his art.

The Indian's patterns are simple, of elemental rhythm and composition. He paints in tempera or with vegetable oils and a few earth colors, on wooden tablets and zinc or copper plates. Few shades and tones are used. The colors are principally red, black and ochre; very seldom, blue and yellow. Thus we see that the Indian takes advantage of the natural colors of the land, the animals and the vegetation of the region in which he lives. His chromatic phantasy is satisfied with the light, the colors, the exuberant and exotic forms of the world of nature that surrounds him.

Often, the Indian artist becomes the translator of facts and incidents from the life of the land because he has a natural ability which is recognized by the community. The particular experience transcribed through his brush may be foreign to him; but not the sentiment that animates him to work. That is part of the faith of the people that nourished him. Neither the Indian nor the *mestizo* was ever confused by problems of technique, form or color. They have a human purpose to accomplish, and they accomplish it.

The industrial repercussions of this art are limited to the community which produced it; its commercial value is unknown.

The missionary of the sixteenth and seventeenth centuries who first widened and improved the workshops, also occupied himself with extending the use of their products. Many of his new techniques were introduced to meet competition and satisfy the demands of the Indian or *mestizo* trade. Upon occasion he gave the

[28]

Indians models to copy, from Spain or the Orient — primitive models easily assimilated by the peasants. He did not attempt to transform the creative force or alter the quality of the artisan's handiwork. He did not try to bring this work into competition with objects that came from Spain into the Mexican cities. He purposed only to provide for the economic needs of the provinces. When the workshop menaced the larger industry of the colony, or threatened to invade the market of a European product — as in the manufacture of playing cards, woodcuts for printing letters, or illustrations for the religious books of the village communities — the Inquisition and the colonial government prohibited, suppressed or secluded the shops in question.

It was during colonial times, when the use of paper was permitted, that prints appeared. At market and carnival the missionary gave them to the Indian who had paid his tribute; from them he learned the Christian doctrine. In this way prints came into popular use. The verses which accompanied the pictures became the medium through which were transmitted the heartaches, the happiness, the aspirations of the peasant. Songs, ballads, romances, through their eloquence or humor, or grandeur even, heightened the dramatic sense and power of the painting. The troubadour who went from town to town, from one carnival to another, selling these prints and singing the verses, accomplished a valuable artistic function.

The painting that the Indian does for the chapel or church is limited almost entirely to curtains or architectural decoration. Very rarely one finds canvases for the altars — almost always small paintings of "ex-voto," later called *retablos* or altar paintings. Painting is also seen in homes and public squares.

Occasionally, in the second half of the nineteenth century, some painters from the fields, without an example to follow or a school to imitate, went to the cities of the interior. The sincerity.

the lack of artistic ideology, the humility with which their occupation was professed, were well received in the small provincial towns, where the citizens aspired to dress their homes with a little of the luxury which they knew to exist in the large city — for news of the life in the salons began to reach them at this period, through the newspapers and through the railroad communications established by the liberal government. So these painters adorned provincial salons in the fashion of the moment, French or Italian, and left works, anonymous and apochryphal, forgotten and lost as suddenly as they appeared, when some new style took possession of the field. Unfortunately, these works had nothing to say of the cultural life of their epoch; they were not understood by the human beings from whom they emerged. Their importance will be announced by contemporary Mexican painting when the primary sources of its aesthetic preoccupations come to meet it.

In this way the painting from the fields has lived for four hundred years. The artistic currents of the first century of independent life did not seek it. It was the triumph of the 1910 Revolution, bringing the fields and the city together which awakened a desire in intellectual circles to discover the significance of this world of contrasts, shades, colors, questions — the artistic conscience that experiences the moment.

# The Moment

WHEN the Revolution began, the intellectuals of the provinces saw the soldiers of the fields — dark, sullen faces, white trousers, wide hats, bullet-straps on their shoulders — leave the plow and the scythe to take up the battle. Some of these intellectuals joined the revolutionaries and invaded the enemy cities with them; and the impact of new sights awakened in them a consciousness, long dormant, of their country and their people as an ethnic group. In the central plateau and in the deserts they saw fields and peasant faces, simple colors and forms, cut in sharp opaque pictures; in the tropics vibrated a life intricate, exotic and luxuriant; and suddenly there loomed a vision of the Indian and the *mestizo* as the vital cultural force in the land.

Through the aggressive courage of the peasant the Revolution triumphs. Meanwhile, the cruelty of war, the physical and moral misery, wipe out artificial conflicts, discourage foreign tendencies. Carried away at first by the economic, political and cultural rift with the old life of the great cities, later by their interest in the research sponsored by the new government, the intellectual now endeavors to penetrate the art of the fields.

The results of these efforts were apparent in the Exhibit of Popular Arts opened under official patronage upon the celebration of the First Centenary of the Consummation of Independence in 1921. The importance of this exhibit was recorded in the first monograph on the subject, compiled and published by the painter Atl. Here was emotional genius that complemented the revolutionary intelligence; an art whose significance parallelled the social ideas of the Revolution. In these popular objects, these prints and *retablos,* the new order found its cultural integration.

In the Mexico of 1922, disparate elements were still fermenting. There still existed isolated feelings of sadness, suffering and

[31]

rebellion. Pictorially, we see shadowy archaic or martyrized representations of the peons and their fields. The ingenuousness of the popular arts, their spontaneity of form and color, remain; their mood now happy, now ironic. Again, there is apparent an active agitation, a violent impulse to define the new experiences and to discover methods adequate to this purpose.

A newly discovered reality provides the subject-matter. Thus the social revolutionary idea precipitates a change in the objectives of art. The social revolutionary idea is the vital interest of the period, defining the form, recreating itself in the design of the ancient codex, in the *retablos,* in the murals of the *pulque* shops of the slums. The themes that find expression through the artist's brush are the ferocity and vigor, the striking attitudes, the strange contours, monstrous or grotesque, that characterize the lives of oppressed peoples.

The composition, the harmony of this developing art recapture something of the spacial definitions of ancient Mexican sculpture, together with the baroque of the Churrigueresque altars. It turns its glance to the geometric rhythm, to the pictorial architecturization of the great Italian painters of the Renaissance; like them, it has found and understood the image, the sense, the life it is to paint. But one thing more is needed before this art can emerge full-statured. When the revolutionary government provides it with materials and a setting, when it turns over to it the walls of the public buildings, the theater of contemporary Mexican painting raises its curtain. . . .

# CONTEMPORARY
# MEXICAN ARTISTS

# ABRAHAM ANGEL
## Born Mexico City, 1905
## Died Mexico City, 1924

SUBTLE, fine, of an ethereal delicacy of form and color, transparent, resplendent, is the painting that Abraham Angel left behind him when he died —"young, as befitted his genius."

His work is an aspect of present Mexican painting, happily not surpassed or imitated. It is therefore not strange that Manuel Rodríguez Lozano in a brief note on this painter said, "In the paradise of America, Abraham Angel is Adam."

His drawings, done with ultra-fine harmonious and rhythmic lines; combined in his painted portraits and landscapes with his peculiarly personal coloring, rich in tones of ochre, violet, opalescent greens, blues and pinks; reveal his emotional interpretation. They are intimately faithful to life in the small towns and provinces of Mexico.

The simplicity of his themes, the attitudes of his figures, the composition, the graceful manner and the abandonment with which he presents his artistic motifs, and the ingenious detail — overlooked by the painter at the moment of creating, yet ever present in a spontaneous and almost childlike manner in his productions — unveil a sensibility bordering very close on the magnificent.

His work, almost entirely in the hands of three or four collectors, reveals a pictorial genius of greatest elegance, simplicity and delicacy in contemporary Mexican painting.

[35]

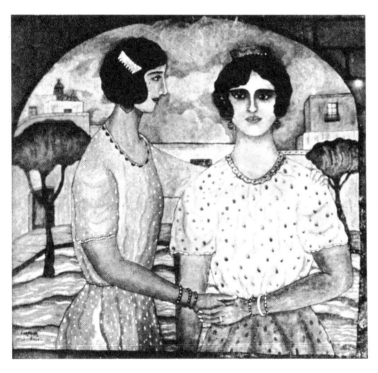

ABRAHAM ANGEL
The Sisters (Oil, 1923), Francisco Sergio Iturbe Gallery, Mexico City

[37]

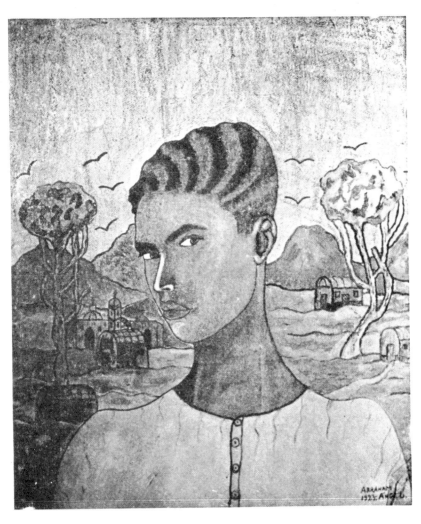

ABRAHAM ANGEL

Portrait of Himself (Oil, 1923), Francisco Sergio Iturbe Gallery, Mexico City

[39]

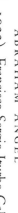

ABRAHAM ANGEL

The Little Mule (Oil, 1923). Francisco Serrio Iturbe Gallery, Mexico City

ABRAHAM ANGEL

Indian Girl (Oil, 1923), Francisco Sergio Iturbe Gallery, Mexico City

[43]

# DOCTOR ATL
## Born Guadalajara, Jalisco, 1887

HE CAME to Mexico City, saw General Porfirio Díaz, and told him that he wanted to study painting in Europe. A few months later he was drinking deep of inspiration in the mountains in Italy.

Poet, author, draughtsman and above all a painter, Atl is the first contemporary landscape painter in Mexico. His work is a projection of the spirit and human feeling towards nature — and life. One finds in it all the rebelliousness and unrest of a mind ever seeking for new sensations and new artistic experiences, constant, yet so multiform. His plastic sense, symbolical and strong, reveals an interpretation of the Mexican landscape of the central plateau, intimately grasped and faithfully expressed.

His share in the Mexican Revolution to which he has belonged since its beginnings, has been fruitful. It was Atl who initiated together with other painters the development of the artistic ideals that the Revolution brought.

He has exhibited in Rome, Paris, New York and Mexico City. His pictorial unrest, to be found in the branches of trees as well as in clouds and mountains, or in skies and craters, overflows in the midst of rocky colorings with sensuality and vigour. He has also tried to find new methods and colors, to produce a "new plastic sensation (*Atl colors — Aqua Resina*), which he has used in his latest productions, and to which he has given an original and austere value.

As an investigator of our popular art, he compiled the first monograph published on the matter and has written, furthermore, monographs on architecture, painting and several literary works, which fully justify the appreciation made of him: " a most unusual personality."

[45]

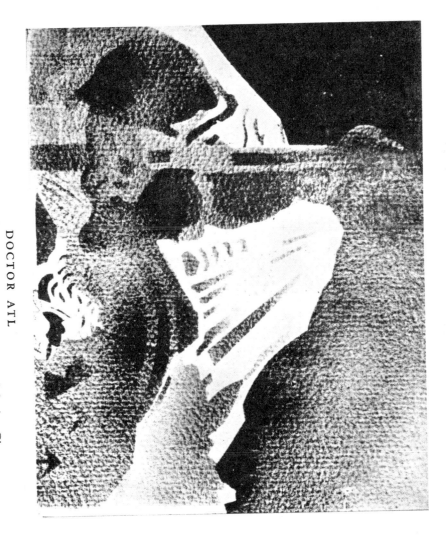

DOCTOR ATL

The Little Houses and the Sun (Atl Colors, 1933). Courtesy Mexican Art Gallery

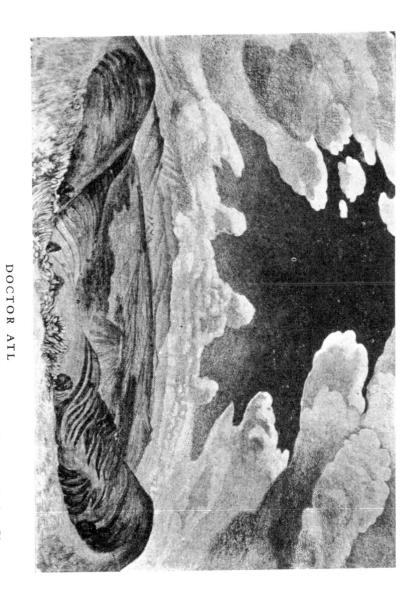

DOCTOR ATL

Clouds Upon the Valley (Agua Resina, 1932), Mexican Art Gallery, Mexico City

DOCTOR ATL

Sky and Precipice (Aqua Resina, 1933), Collection Alberto J. Pani, Mexico City

[53]

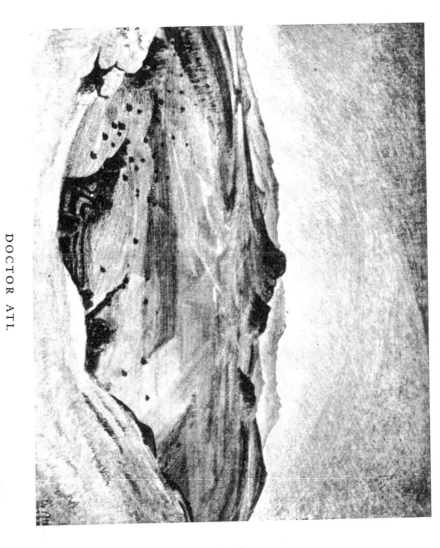

DOCTOR ATL
The Valley of Mexico (Atl Colors, 1933), Collection Agustín Velázquez Chávez, Mexico City

[55]

# JULIO CASTELLANOS
## Born Mexico City, 1905

GEORGE BOAS, in reviewing on the Pan-American Art Exhibition in Baltimore at which fourteen countries of the Americas, with a total of a hundred and thirty-four painters, were represented, wrote: "Though Mexico sent a Rivera and an Orozco, they were in no sense of the word the best or most typical products of these men. The Castellanos 'Woman Washing a Child' is a much better picture than either of theirs." Universal attention then began to be paid to Julio Castellanos.

This young artist, compelled by his thirst for wider horizons and broader fields in which to develop his personality, interrupted his studies at the Academy of Fine Arts of the City of Mexico to travel through America and Europe. He has held exhibitions of his paintings in Buenos Aires, Paris and New York City.

He took part in the Mexican Art Exhibition held in 1931 in eight different cities of the United States under the patronage of the American Federation of Arts; in the traveling exhibition patronized by the College Arts Association in 1934; as well as in the exhibitions of contemporary Mexican art sent by the Mexican Art Gallery of the City of Mexico to Seattle, Washington and Cambridge, in 1936.

He has done lithographs and designed theater decorations for plays given during the 1934 season at the Palace of Fine Arts under the direction of Antonio Castro Leal. For several years he has been a teacher of the Plastic Arts Department in the Ministry of Public Education.

His drawings, characterized by simplicity and precision of outline, by well-balanced forms with soft lines, have appeared in Mexico in different literary journals and magazines of the plastic arts. Cardoza y Aragon has said: "They express sensibility; but

even more than sensibility, talent. In them his voice is more intimate, and more persuasive, more strictly submissive to line and shadow."

His admirable fresco at the Primary School of Coyoacan (1933), discloses a joyful riot of form, line and color, animating the themes, the figures, and the composition.

JULIO CASTELLANOS
Surgery (Lithograph, 1935), Mexican Art Gallery, Mexico City

[59]

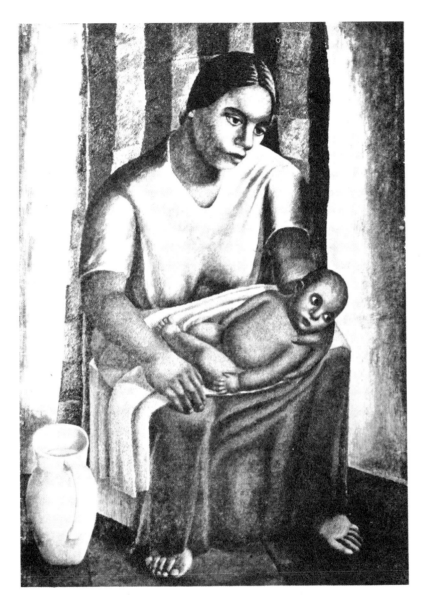

JULIO CASTELLANOS

Mother With Child (Oil, 1932), Weyhe Gallery, New York City

[61]

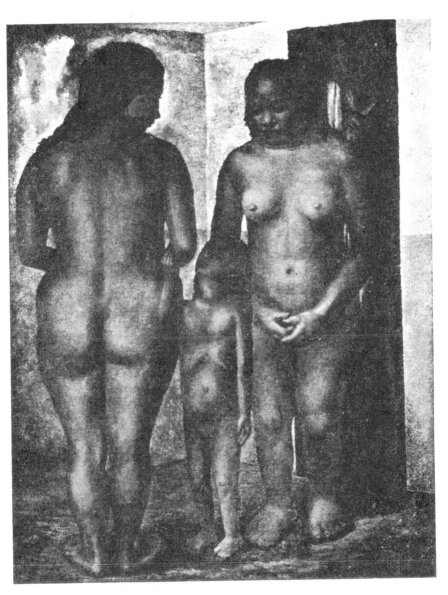

JULIO CASTELLANOS
The Aunts (Oil, 1933), Courtesy Weyhe Gallery, New York City

[63]

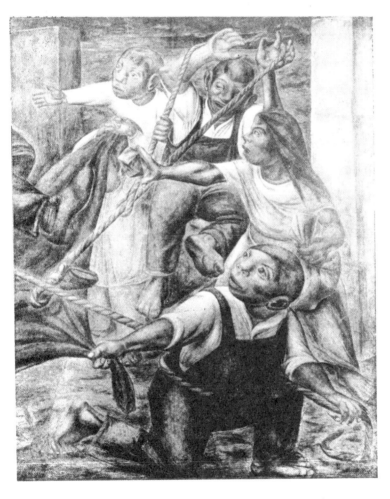

JULIO CASTELLANOS

Joyful Riot — *detail* (Fresco, 1933), Primary School, Coyoacan, Mexico

[65]

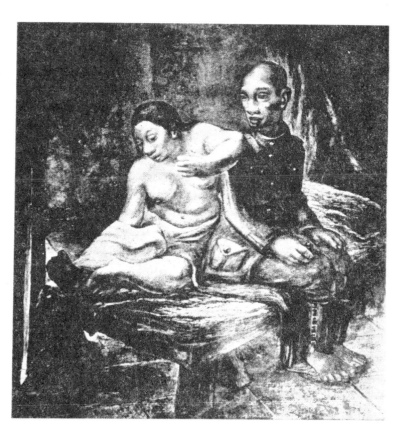

JULIO CASTELLANOS

Dialogue (Oil, 1936), Mexican Art Gallery, Mexico City

[67]

# MIGUEL COVARRUBIAS
## Born Mexico City, 1904

SPEAKING of caricatures, Samuel Ramos says of Covarrubias: "He has caught Harold Lloyd in his shark-like laugh, and Chaplin in the convulsive contraction of a mouth that no longer knows how to laugh. The comical part of a caricature lies in the contrast between the changing mobility of a person and a paradoxical impression of the same person fixed in a movement that condemns it to perpetual immobility."

Unconscious of this psychological analysis, Covarrubias has gone even further and has achieved in his paintings of types, customs and aspects of Negro, Mexican, American and European life, something more than a caricature. They are a plastic interpretation achieved through his own modes of expression and personal technique.

His name and art are now known all over the world. Many of his illustrations and caricatures have been published in *Vanity Fair, Creative Art, Harper's Bazaar, Art News,* and other United States and Mexican magazines.

In 1925, his book of caricatures entitled *The Prince of Wales and other Famous Americans* was published in New York by Alfred A. Knopf. This date marks the beginning of a series of similar books which he has had published since then.

He has also illustrated many books, painted scenery for the Theatre Guild of New York, executed and exhibited lithographs, oil paintings and water colors. The American Federation of Arts, the College Arts Association, and the Mexican Art Gallery have included him in their circulating exhibitions, always commenting very warmly upon his work.

[69]

Covarrubias' pictorial expression is able and vital. His latest productions show a strong feeling for movement and color. Without being dramatic in content, they are characterized by the sharp and precise conception of the life that they portray.

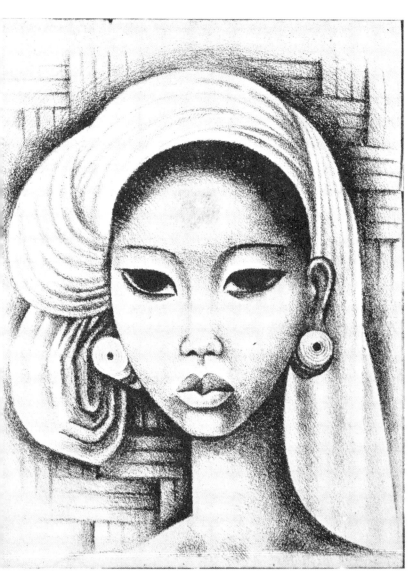

MIGUEL COVARRUBIAS

Bali Girl (Lithograph, 1935), Mexican Art Gallery, Mexico City

[71]

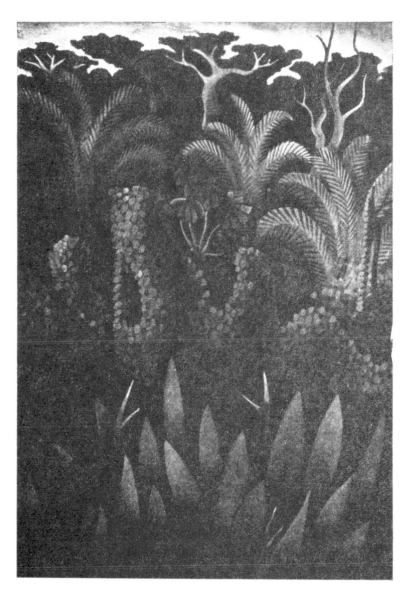

MIGUEL COVARRUBIAS
Tropical Forest (Oil, 1932), Courtesy Mexican Art Gallery, Mexico City

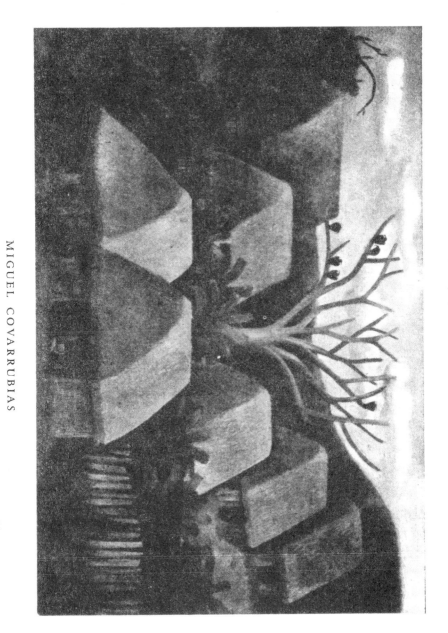

MIGUEL COVARRUBIAS

Tropical Town (Oil, 1931). Courtesy Mexican Art Gallery, Mexico City

[75]

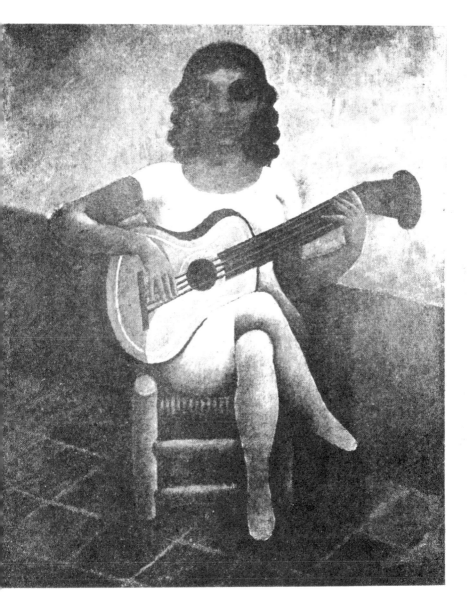

MIGUEL COVARRUBIAS
Young Girl (Oil, 1932), Courtesy Mexican Art Gallery, Mexico City

[77]

# FRANCISCO DIAZ DE LEON
## Born Aguascalientes, 1897

DIAZ DE LEON took his first drawing lessons at the municipal academy of the town where he was born. In 1917 he was given a scholarship by his home state in order to study in Mexico City at the National School of Fine Arts, where he remained for two years. Disagreeing with the official methods of teaching, he gave up his scholarship and set out to seek by himself, in accordance with his own tendencies, the path he was to follow. Later, the National School of Fine Arts was reformed, and he was appointed teacher of painting in 1929 and continued there for thirteen years.

He was one of the founders of the Open Air Painting Schools and directed the one established at Tlalpam from 1925 to 1933, when he became director of the Central School of Plastic Arts (formerly the National School of Fine Arts).

The present advance of the graphic arts in Mexico is due in a large measure to Díaz de León, to whom Antonio Castro Leal intrusted the typographical supervision of the publications issued by the Palace of Fine Arts in 1934.

His principal pictorial activities consist of engravings, woodcuts, lithographs and etchings, at which he has worked since 1922. Woodcuts had been abandoned by Mexican artists till the year when this artist revived them, forming engraving classes which began work in the Open Air Painting Schools. The development which this art has since that time had among us, was shown on the occasion of the first collective exhibition of prints held at the Mexican Art Gallery in 1935. Works of fifteen contemporary Mexican artists were represented at this exhibition, the organization of which was entrusted to Díaz de León.

There is in De León's engravings loveliness of form and gentleness of line, united with a fresh and peaceful feeling of Mexican life. In his lithographs and dry points, he shows a striking knowledge and appreciation of the graphic values of these mediums of expression, which he has thoroughly mastered, achieving an adequate use of their resources and possibilities.

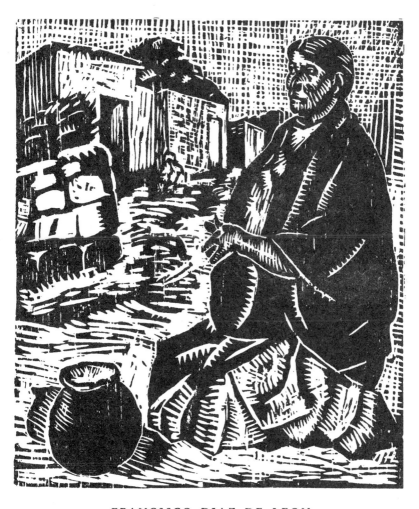

FRANCISCO DIAZ DE LEON

Woman (Woodcut, 1922), Collection Agustín Velázquez Chávez, Mexico City

[81]

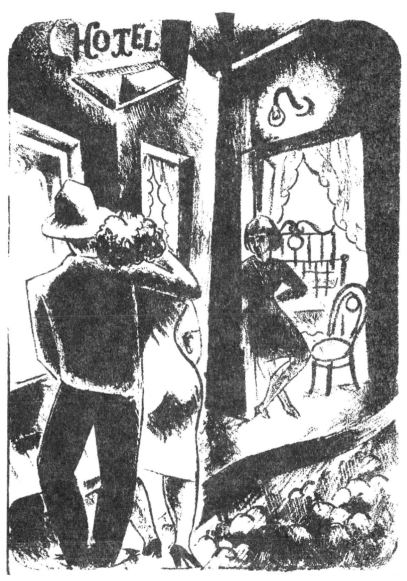

FRANCISCO DIAZ DE LEON
Night Scene (Lithograph, 1930), Central Art Gallery, Mexico City

[83]

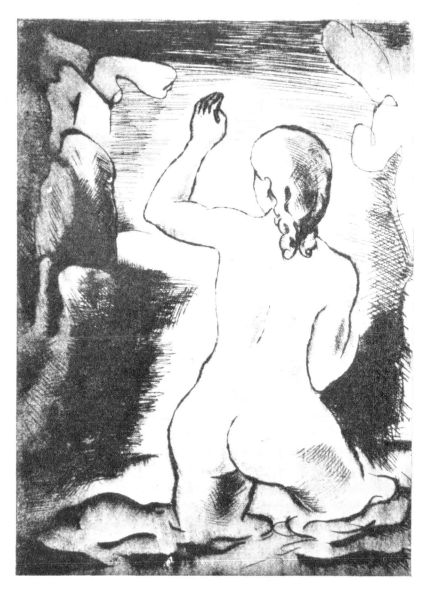

FRANCISCO DIAZ DE LEON

he Bath (Drypoint, 1935), Collection Agustín Velázquez Chávez, Mexico City

[85]

# GABRIEL FERNANDEZ LEDESMA
## Born Aguascalientes, 1900

FERNANDEZ LEDESMA has the indirect satire of the ironical. All his figures are pictorial fits of laughter in green and red tones, which he combines with the yellows and browns of his lighting effects. The attitudes of his characters, sometimes offensive and sometimes decidedly queer, reveal with subtleness Mexico's popular life.

When a child, through his contact with potters, he acquired that passion for popular arts and crafts that has marked his career. For two years he studied in the National School of Fine Arts. Then, in 1921, he was commissioned by the National University to decorate the pavilion of the Mexican Republic in Rio Janeiro, Brazil. He took charge in 1923 of the artistic direction of the Ceramics Pavilion of the Faculty of Chemical Sciences. During 1924, he was a professor at the National School of Fine Arts. With other painters, he formed in the years 1925-1926 the revolutionary group of artists known as "30–30."

As the director of *Forma,* the review of plastic arts, he revealed the different aspects of the contemporary movement in painting, publishing reproductions and interesting commentaries on popular art. After directing one of the Open Air Painting Schools, he was put in charge of the Art Hall of the Ministry of Public Education, where some of the most interesting exhibitions of Mexican and foreign contemporary art have been held in a worthy manner. Besides the special significance with which he has surrounded these exhibits, touching upon their educational and artistic values, Fernández Ledesma has encouraged, through pamphlets and posters in the Hall of Art, new typographical forms and arrangements.

His work has been fruitful. Besides his easel paintings he has produced fine woodcuts, engravings, drypoints and monotype paintings, which he has exhibited several times at the Mexican Art Gallery. He has, furthermore, designed theater decorations for plays that were given during the 1933 season of the Teatro de Orientación of the Ministry of Public Education, and for the presentations of the Teatro de la Universidad at the Palace of Fine Arts in its 1936 season under the direction of Julio Bracho.

His latest paintings reflect an enigmatic, pitiless irony, the origin of which is to be found, perhaps, in the plastic decoration of toys and other products of popular art.

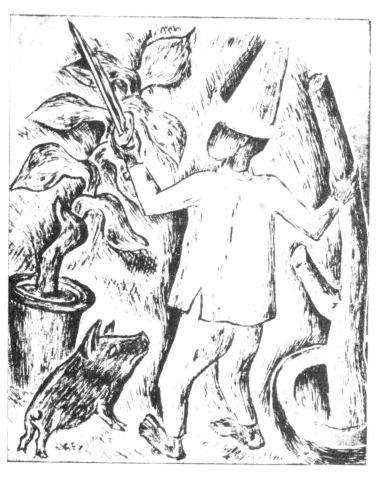

GABRIEL FERNANDEZ LEDESMA
Man from Yucatan (Monotype, 1935), Mexican Art Gallery, Mexico City

[89]

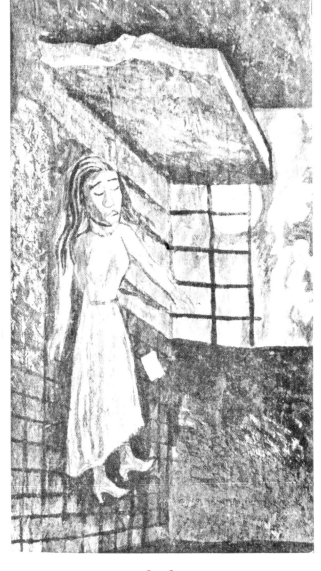

GABRIEL FERNANDEZ LEDESMA

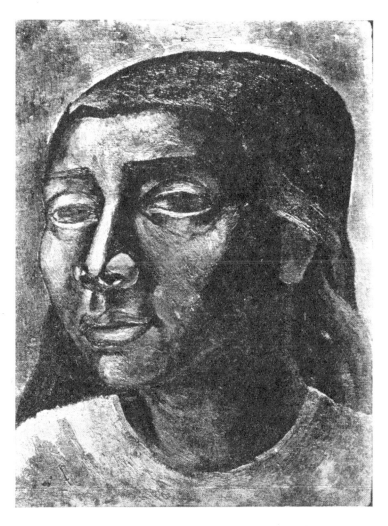

GABRIEL FERNANDEZ LEDESMA
Head in Green (Oil, 1934), Mexican Art Gallery, Mexico City

[93]

# FRANCISCO GOITIA
## Born Zacatecas, 1884

IN a certain sense Goitia is unique. Away from the city, separated from artistic circles and from the "official" currents affecting others, Goitia lives teaching drawing to the children in the schools of Xochimilco — an Indian village of floating gardens in the valley of Mexico — in a situation as modest as his work. His painting characterized by its purity of sentiment and by an incomparable emotional depth, is worthy of one of the first places in Mexican plastic arts.

When still a very young man Goitia came to Mexico City, where he studied at the Fine Arts Academy. He worked as a painter and as a printer of engravings. In 1904 he went to Europe. After traveling in Italy, he studied in Spain under Francisco Galí, and held an exhibit in Barcelona, where the local museum acquired a collection of his works. In 1912 he returned to Mexico to join the revolutionary forces commanded by General Angeles. It is then that he witnessed "as an attentive artist, the social movement of the period" through the struggles occurring in the north of the Republic.

Upon the triumph of the Carranza forces, Goitia returned to Mexico City, whereupon Manuel Gamio commissioned him to make a study of the inhabitants of the valley of San Juan Teotihuacan; and Goitia went to seek "the heartaches of the race through its past and present sufferings." Until that time his activity as a painter consisted of experimentation and study. Now he found his long-sought inspiration. The soil and the race, in its most expressive aspects, he reveals in his painting with strikingly personal interpretations in which the misery, sorrow and suffering of man constitute the social themes. A great quantity of studies,

notes, sketches — carbons, pastels and watercolors — some of them found in the reception room of the Under-Secretary of Public Education and others in private collections, remains from that period.

In 1924, on the occasion of the lectures given in Carnegie Institute, Washington, D. C., by Manuel Gamio — who aided Goitia in accomplishing his work — an exhibition of his paintings was presented. In 1925 he went to Oaxaca to study further the Indian race. He painted canvasses, with his own distinguished technique, of a shadowy and archaic appearance, expressing the martyrized sentiment of the figures he portrays. Scenes of the Revolution, "poor people," beggars, wounded men, people of the common folk weighed down by their physical and moral misery, he rendered in unprecise and somewhat indifferent outline, in distant-gray colors diluted by the brush to far-away tones, in the spirit of their life itself. Such are the themes which his sincerity and spontaneity have humanized with an artist's emotion.

Goitia, a mystical spirit, intoxicated with his own emotion, is like an artist of the Middle Ages. More than the enrichment of the plastic arts, through experiments and new technical processes, he leaves to his race and to his period a sentiment of communion with mankind.

FRANCISCO GOITIA

Sketch (Charcoal, 1915), Courtesy Mexican Art Gallery, Mexico City

[97]

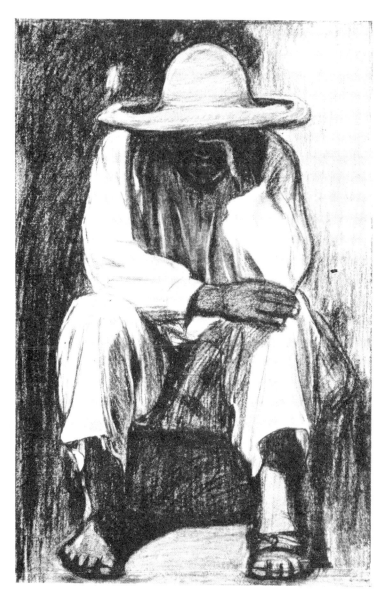

FRANCISCO GOITIA

The Indian Peon (Charcoal, 1920), Ministry of Public Education, Mexico City

[99]

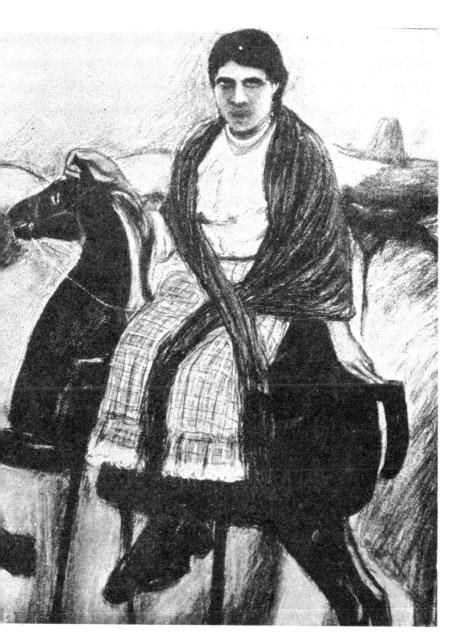

FRANCISCO GOITIA

Merry-go-round (Pastel, 1924), Ministry of Public Education, Mexico City

[101]

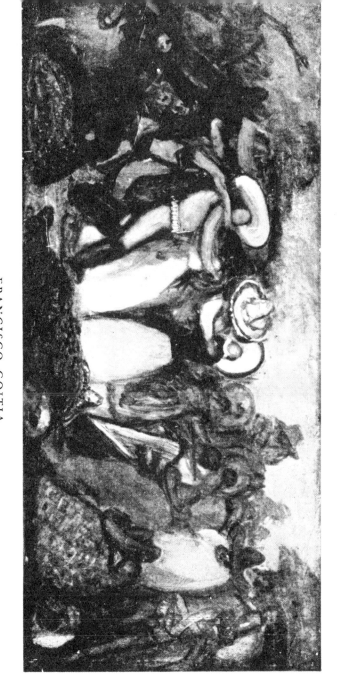

FRANCISCO GOITIA

Revolutionary Dance (Oil 1918) Courtesy Mexican Art Gallery, Mexico City

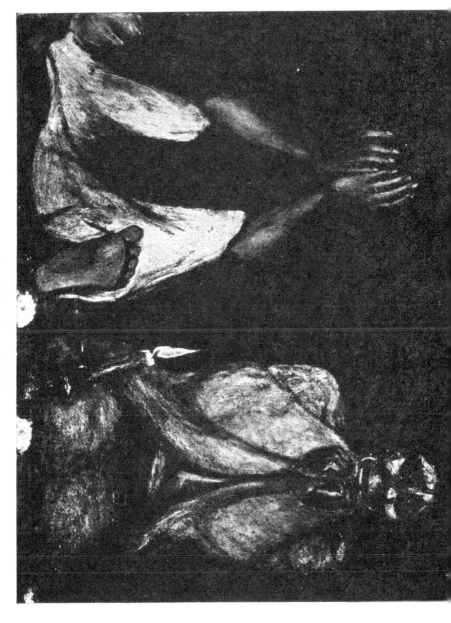

# JESUS GUERRERO GALVAN
## Born Tonila, Jalisco, 1910

GUERRERO GALVAN began to study art in the School of Plastic Arts at San Antonio, Texas, where he painted the walls of the school building. Later he occupied himself painting railroad tanks, cars and mural advertisements.

Returning to Guadalajara in 1922, he studied at the painting shop of José Vizcarra. Here he joined the group of paint workers organized under Zuno in 1924. His work of that period revealed an admirable plastic ability, which in theme, form and color differs completely from that disclosed in his present work. The portraits and figures that he painted then contained a typical aspect of the people of Jalisco, and were a sort of resumé of tendencies observed by Guerrero Galván in Mexican painting of the nineteenth century, and in artistic circles in which he had lived.

He came to Mexico City in 1925, where he joined the group of revolutionary painters. It is then that he abandoned portrait painting and the static aspect which characterized his earlier work. In a somewhat lyrical manner, he now took up imaginative and abstract painting, for several years working by himself, without exhibiting. Entering into the service of the Department of Fine Arts, he devoted time to the teaching of plastic arts in primary schools. This contact with the masses of school children opened to him new fields of inspiration, manifested in paintings of great dimensions and vast proportions (executed after trying out fresco, tempera, and a mixture of colors diluted in gasoline), through which his pictorial sensibility is expressed with great fidelity as well as earnestness and social significance. In 1934, he revealed clearly this new aspect of his painting in the fresco of the primary school at Portales, executed together with other painters.

Intensely interested in life and human character, he has taken his art into the field of drama. In 1935 he designed and painted the stage scenery for the play *Quetzalma* written by Julio Bracho and staged at the Teatro de Orientacion, and in 1936 he designed the decorations and costumes for the ballet *Tribu,* presented by David Ayala at the Palace of Fine Arts.

Besides his easel paintings and fresco murals, he has done woodcuts, lithographs and engraved drypoints. The Mexican Art Editions included him among the artists represented in the First Series of Albums of Art, published in 1936.

The content of his latest work discloses an ideological unrest manifested in subjects and figures which, without being popular or picturesque, do savor of the Mexican people. In them, he depicts melancholy, irony and expectation by the use of simple and cutting lines, animated by a growing pictorial vigor. His composition, which shows furthermore an original pictorial harmony, enhances this vigor by means of the sober, dry color which, without being gray, unveils the dark and light tones of blue, rose and ochre.

Of all painters mentioned within these pages, he is the youngest, and has been up to this time, the most notable of his generation.

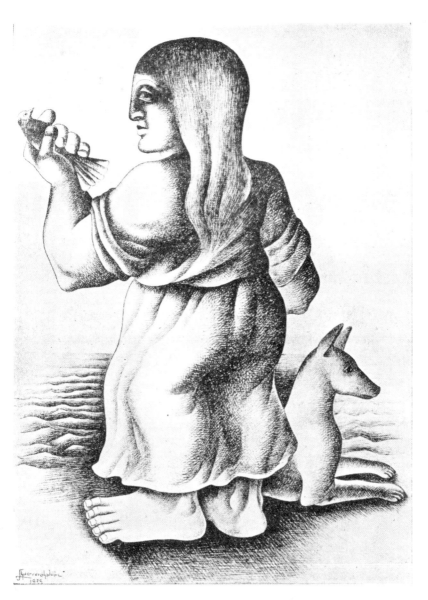

JESUS GUERRERO GALVAN
The Bird (Tempera, 1935), Mexican Art Gallery, Mexico City

[109]

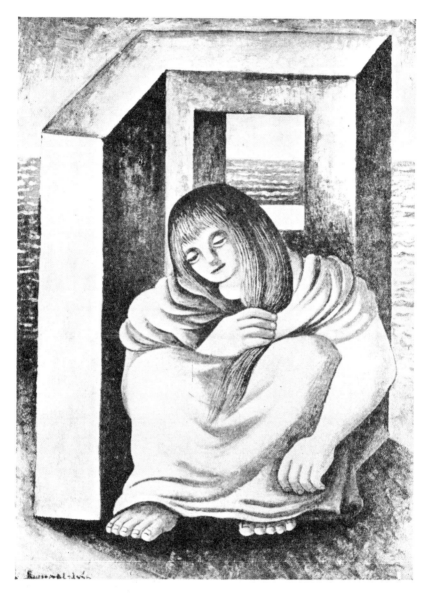

JESUS GUERRERO GALVAN
Woman (Oil, 1935), Collection Agustín Velázquez Chávez, Mexico City

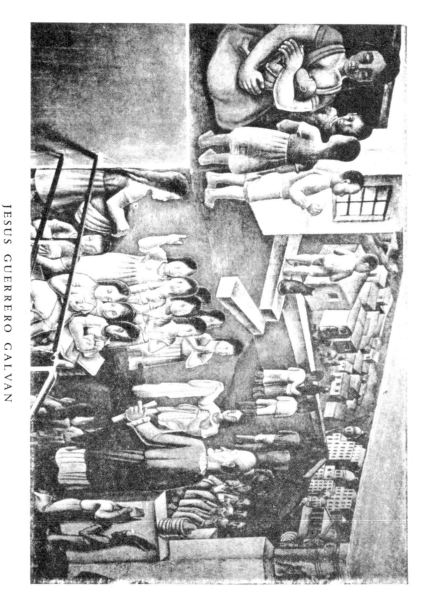

JESUS GUERRERO GALVAN

Teaching — *detail* (Fresco, 1934), Portales Primary School, Mexico City

[113]

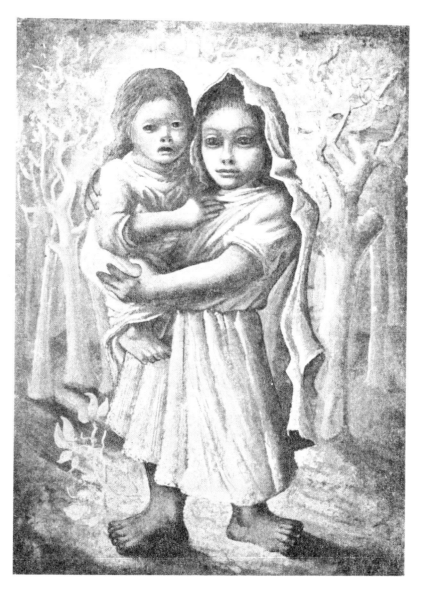

JESUS GUERRERO GALVAN

Peasant Children (Oil, 1936), Collection Agustín Velázquez Chávez, Mexico City

[115]

# MARIA IZQUIERDO
## Born San Juan de los Lagos, Jalisco, 1906

MARIA IZQUIERDO has attracted and deserved the unanimous attention of the Mexican intelligentsia. On the occasion of her exhibition at the Gallery of Modern Art, Diego Rivera wrote of her: "The talent of this young artist is well balanced and fiery, but reserved and contained, and develops more at depth than at the surface. In the few years she has lived, the current of life must have left much sediment in the subconscious depths of her mind; if one gazes into her eyes or at her paintings, one perceives, deep down, particles of flint and dust, of iron and gold."

She has exhibited in New York City, and Frances Flyn Paine claims that she is "the first Mexican woman to show her work in the United States." In February, 1933, on the occasion of the watercolor exhibition organized by Frances Toor, with whom Maria has worked for a long time, Jorge Cuesta observed in her paintings "that quality that makes her art akin to cubism, 'fauvism' and even to certain aspects of surrealism." Celestino Gorostiza has pointed out that "the subjects of her pictures respond to a natural selection made by her spirit and there is therefore nothing strange in the fact that the circus is the most constant source of her inspiration, as in it one may find, in a latent state, the elements of her interest."

In November, 1933, she had another exhibition which awakened considerable interest. Commenting upon it José Gorostiza said: "María Izquierdo is not to be found in the subjects she chooses. Nor may she be discovered, as one would think, in her peculiar way of treating them. although we can but praise the energy with which she resists falling into the natural gracefulness of watercolor, to give this technique instead a soberness and

strength that counteract, almost to the point of annulment, the real state of mind that induced her to seek refuge in it."

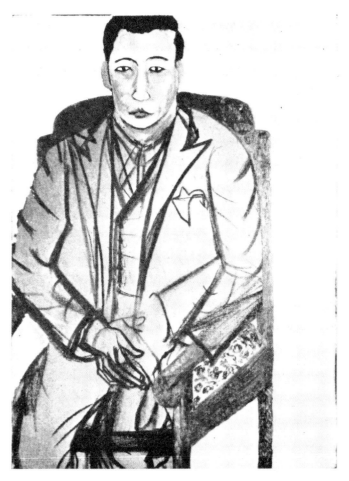

MARIA IZQUIERDO

Portrait of Dr. López (Oil, 1927), Private Collection, Mexico City

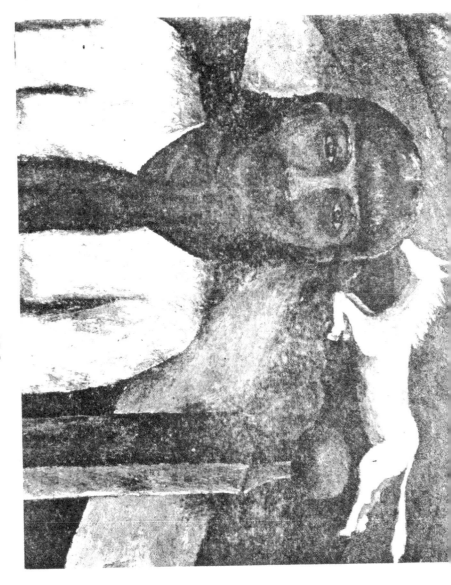

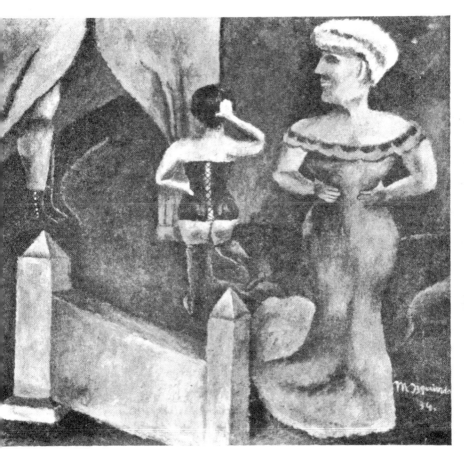

MARIA IZQUIERDO

Entre-acte (Oil, 1934), Private Collection, Mexico City

[123]

# AGUSTIN LAZO
## Born Mexico City, 1900

A PAINTER of refined sensibility, Lazo studied at the Academy of Fine Arts in Mexico City and in the museums of France, Italy, Germany and Belgium, and for some time with Alfredo Ramos Martínez. There have been exhibitions of his works in Paris and New York, and several "one man shows" in Mexico City, and he has been represented in the collective exhibits presented by the Mexican Art Gallery (1935-36).

The delicacy of his painting and the elaborateness of his pictorial expression lead him to pen drawings and watercolors in which he reveals an extraordinary refinement.

Of his oil painting, Xavier Villaurrutia says: "On no side of Lazo's canvasses shall we find a shadow of eloquence. This painting is modest, incisive." In his pictures of Mexican life painted in 1926-29, his pictorial irony develops swiftly. The coloring of these productions is a city-gray that embraces the seven primary colors of the rainbow. Parlors, the bourgeoisie, city maidservants and robust serious children are the usual themes of these pictures. Fine combinations of horses and riders follow, done in pen and ink in the manner of Chirico, Picasso, Klee and Dix, and illuminated with watercolors. These are distinguished by their delicacy of form and color.

Restricting not only the field of his inspiration, but his realistic approach as well, he has developed his painting from "the real" to "the imaginative," ending up as a scene painter. For the season at Teatro Hidalgo (1932) he decorated the scenery for *The Karamazoff Brothers* as well as for *The Double Mrs. Morli*. For the Teatro de Orientación of the Ministry of Public Education, for the 1932-34 seasons, he painted the scenery for *Antigone, Macbeth,*

*Requesting Her Hand, Entremés del Viejo Celoso, The Marriage,*
*Dr. Knock, Liliom, Georges Dandin, A l'ombre du mal, Ifigenia* by
Alfonso Reyes; *En qué Piensas* and *Parece Mentira* by Xavier
Villaurrutia, *Ser o no Ser* and *La Escuela del Amor* by Celestino
Gorostiza, as well as the scenery and costumes for the Greek
Theatre productions staged by Julio Bracho in 1936 at the Palace
of Fine Arts. In all this scenery his talent discloses decorative
designs of a happy conception, rich imaginative value, and stylized
rhythm, which place him in the first rank of Mexican theatrical
plastic artists.

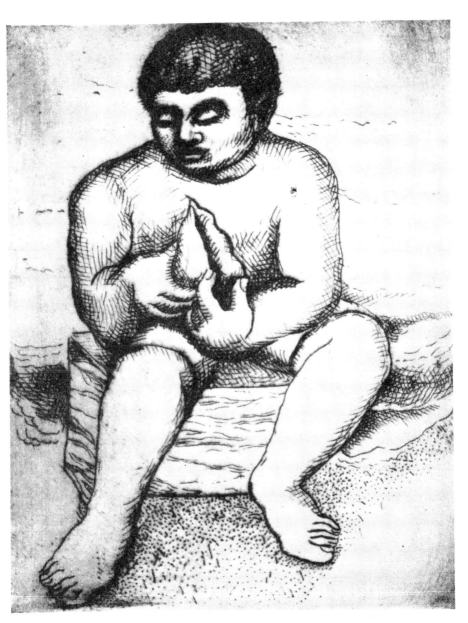

AGUSTIN LAZO

Sleepy Child (Drypoint, 1935), Mexican Art Gallery, Mexico City

[127]

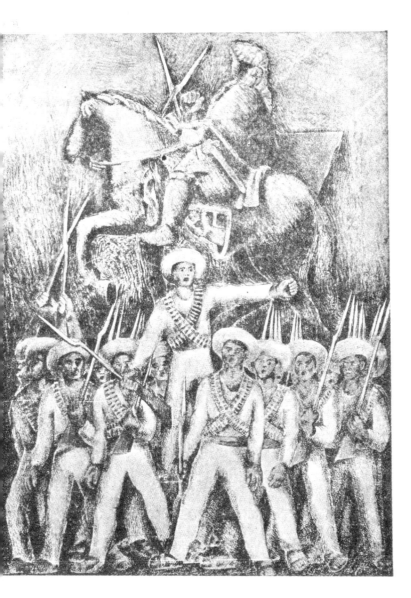

AGUSTIN LAZO

volution (Watercolor, 1932), Collection Genaro Estrada, Mexico City

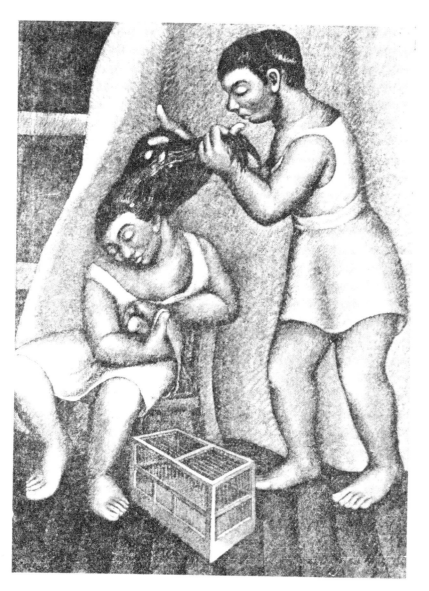

AGUSTIN LAZO

Music (Oil, 1934), Collection Spanish Embassy, Mexico City

[131]

# FERNANDO LEAL
## Born Mexico City, 1900

LEAL studied painting from nature until 1920. At the National School of Fine Arts, and at the Open Air Painting School in Coyoacan, he devoted himself to oil paintings of figures, landscapes and still life.

After his first exhibition in this school he was appointed a teacher there, a position which he filled for seven years. In 1921, together with Jean Charlot, he devoted himself to woodcuts, and presenting the results of this activity in the exhibition organized in 1929, at which more than twenty-five artists presented more than one hundred and fifty prints.

In 1922 he began to cover canvases with subjects taken from scenes of the Mexican Revolution. He was intrusted with the decoration of a mural in the National Preparatory School, where he developed as themes the Indian dances of the village of Chalma.

In 1927, he decorated, al fresco, the entrance to the laboratories of the building of the Department of Public Health, where he used aspects of Indian life as motifs of his paintings.

Leal took an important part in the publication of a review called "30–30," the then current organ of the painters of Mexico, which came out first in 1928. This publication was characterized by articles, reviews and illustrations opposed to academic ideas, and by its original methods of exhibiting the works of the painters in this group.

In 1931 Leal painted with encaustic the vestibule of Bolivar Hall, developing a historical and symbolical theme derived from various events of the wars of independence in South American countries.

Working in collaboration with the sculptor, Federico Cannessi,

he took part in a sculpture competition in 1934 and won the second prize. As the art critic of the newspaper, *El Nacional Revolucionario,* he published weekly, during the years 1934–35, interesting reviews and criticisms on the plastic arts. He has, furthermore, illustrated books and done some woodcuts for posters.

The Mexican Art Gallery has included his easel works in collective exhibitions presented in Mexico and abroad.

FERNANDO LEAL

)ance (Woodcut, 1924), Collection Augustín Velázquez Chávez, Mexico City

[135]

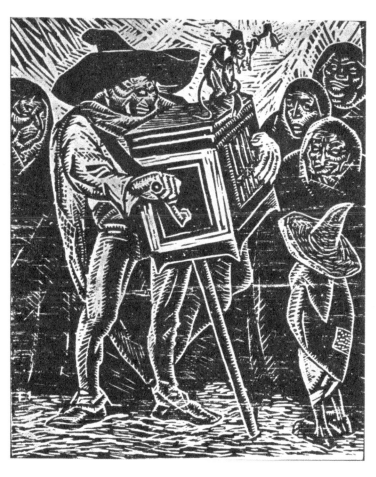

FERNANDO LEAL

The Organ Player (Woodcut, 1925), Mexican Art Gallery, Mexico City

[137]

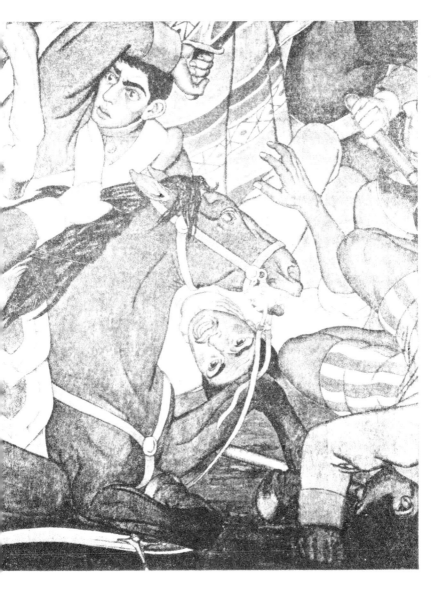

FERNANDO LEAL

The Battle of Junin — *detail* (Encaustic, 1933), Bolivar Hall, Mexico City

# LEOPOLDO MENDEZ
## Born Mexico City, 1903

LEOPOLDO MENDEZ is one of the artists who shows greatest pictorial honesty in his work and in the political and social independence of his inspiration. Radical in his attitude and rebellious against the tendencies of "pure" art, he also possesses a delicate sensibility and supreme pictorial ability.

While studying at the Academy of Fine Arts in 1920, he formed, together with other artists, a center of painting at Chimalixtac, where new techniques in both the practice and teaching of the plastic arts were experimented with.

In 1925 Mendez was a member of the *"Estridentista"* movement, started in Mexico City by Manuel Maples Arce, Germán Lizt Arzubide, Alva de la Canal, Arqueles Vela, and Germán Cueto; and characterized by the "social, literary and revolutionary" impetus that it aroused in Mexico.

In 1932, as head of the section of plastic arts in the Ministry of Public Education, he carried on an investigation of the teaching of plastic arts in the schools throughout the republic, and discussed with the teachers of painting the various problems and the methods to be adopted. This research culminated in the elaboration of a large teaching program.

For more than ten years Méndez devoted himself to engraving. His engravings have appeared in books, magazines, posters and leaflets. In New York, San Francisco and Milwaukee there have been exhibitions of his engravings. The College Arts Association included five originals in its traveling exhibition of Mexican Art (1934–36), and the Mexican Art Gallery has shown a collection of his prints in exhibitions in Memphis, Tennessee; Cambridge, Massachusetts; and Columbus, Ohio.

Méndez' work is not made for galleries and museums. It is an art of "action," intended for the people. It cannot be identified with limited groups or tendencies, for its content and emotional force are drawn from Mexican economic and social problems. The sincerity of his expression has sometimes offended against certain aesthetic proprieties precisely on account of the purity of his emotion; but this cannot but justify and ennoble it.

During recent years his activity in art has been closely related to the idea of giving the artist standing as a worker. This he has been able to accomplish through the League of Revolutionary Writers and Artists of Mexico City.

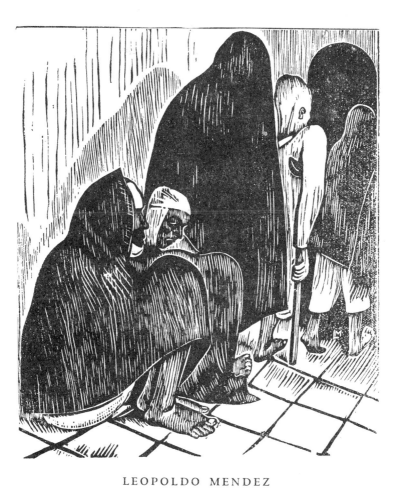

LEOPOLDO MENDEZ

Beggars (Woodcut, 1931), Collection Agustín Velázquez Chávez, Mexico City

[143]

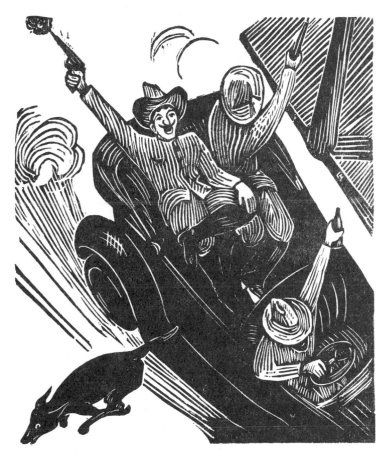

**LEOPOLDO MENDEZ**

Spree (Woodcut, 1930), Courtesy **Mexican Art** Editions, Mexico City

[145]

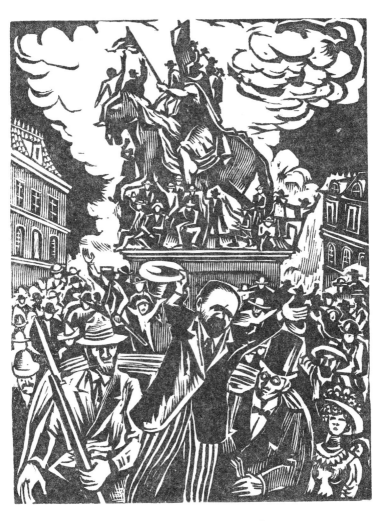

LEOPOLDO MENDEZ
Ballad of Francisco Madero (Woodcut, 1934), Collection Celestino Herrera,
Pachuca, Mexico

[147]

.

# CARLOS MERIDA
## Born Guatemala, 1893

MERIDA first studied painting in Paris under Van Dongen and Anglada Camarassa (1910–14). While in Europe he also worked with Modigliani, and published some of his drawings in Paris. He has traveled through France, Holland, Belgium, Spain and the United States.

Late in 1914 he returned to Guatemala, where he made his first attempts in American painting, based on folklore themes. Coming to Mexico City in 1919, he exhibited his Guatemalan work at the Academy of Fine Arts (now the Central School of Plastic Arts).

In 1921 he joined the group of revolutionary painters and identified himself with the present pictorial movement of Mexico. His mural work of those years is to be found in the Children's Library at the Ministry of Public Education.

In 1927 he went to Paris again, had an exhibition (Galleries des Quatre Chemins), and renewed his contact with the most modern tendencies in painting. At this point his work underwent a total transformation as an expressive medium without losing its traditional line. He has abandoned more and more his folklore themes and the merely picturesque, and attempted to realize a more plastic and more pictorial work.

In 1930, he started a cycle of work with surrealist plastic tendencies. "All the work belonging to this period," Howard Parker says, "shows a great variety of themes, of methods, of formal representations, and of emotions contained and conveyed. The essence of this later work, born of a unified sentiment, although based on, or derived from, his former pictorial experiences, aspires to new and more lyrical results. The essence of this

work of pure abstraction, overflowing with imagination and penetrating even into the depths of the subconscious, is fantastically and magnificently conceived. In it, in modern language, he renews and creates anew the plastic affirmations of a very ancient tradition."

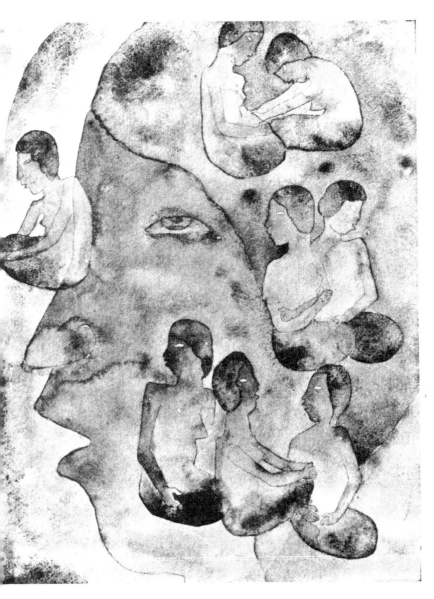

CARLOS MERIDA

Profiles (Watercolor, 1928), Collection E. J. Rice, New York City

[151]

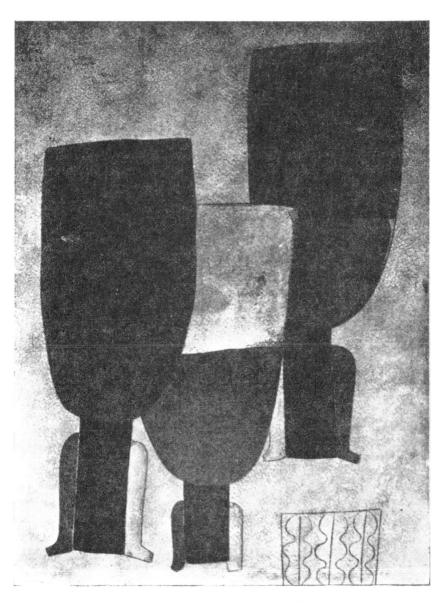

CARLOS MERIDA

Number 28 (Watercolor, 1932), Courtesy Mexican Art Gallery, Mexico City

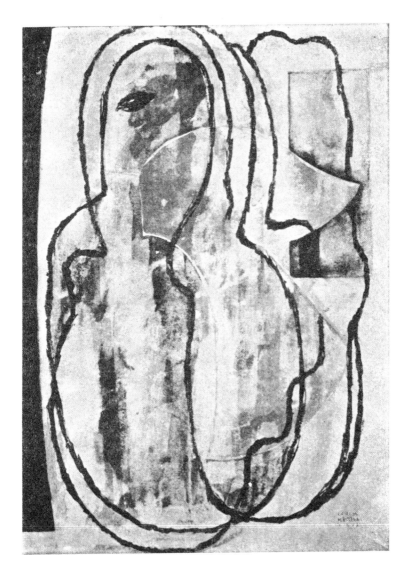

CARLOS MERIDA

Lines (Watercolor, 1932), Collection A. Mack, San Francisco, California

[155]

# ROBERTO MONTENEGRO
## Born Guadalajara, Jalisco, 1885

In Mexican plastic arts, Roberto Montenegro stands for versatility of genius. An etcher, a draughtsman, a painter, an engraver, a scene designer, he has illustrated books, he has engraved on metals, wood and lithographic stone, he has decorated libraries and halls, he has been a publisher of books, an investigator of popular arts and a tradesman in tin toys, adornments and objects.

He began his artistic career at the Academy of Fine Arts in Mexico City, where he studied — like Diego Rivera, Saturnino Herrán and Francisco de la Torre — under Fabrés. His work has been exhibited twice in Paris, once in London, once in Buenos Aires, twice in Madrid and Barcelona, once at Palma de Mallorca, and several times in Mexico, both in "one man shows" and in the collective exhibitions presented by the Mexican Art Gallery in the city of Mexico and abroad.

He began mural painting in 1920 with a fresco called "The Feast of the Cross" in the old monastery of Peter and Paul, and with the "Hall of Free Discussions" in the former church of the same name. In the latter he designed, furthermore, two stained-glass windows whose decorations are based on popular themes. Later, he painted the reception room of the Ministry of Public Education, the Hispanic American Library, the theatre of the Normal School, the court of the annex to the National Preparatory School, and the Lincoln Library of the Benito Juárez School.

His research into popular art culminated with his appointment as first director of the Museum of Mexican Popular Art. This museum was opened in the Palace of Fine Arts in 1934 by Antonio Castro Leal, who commissioned Montenegro to paint the stage scenery for "The Simoon" by Lénormand.

[157]

He has published and illustrated books, edited monographs on his own work, and contributed to the investigation of Mexican Arts and its present tendencies by compiling material for monographs on popular art and on the painting of the nineteenth century.

Regarding his activity, Hermilo Abreu Gómez has written "His aesthetic points of view could be defined by saying that his spirit is attempting constantly to transform his means of expression within his most intimate artistic principles. In this manner his methods have been improving within the possibilities of a well poised artistic consciousness."

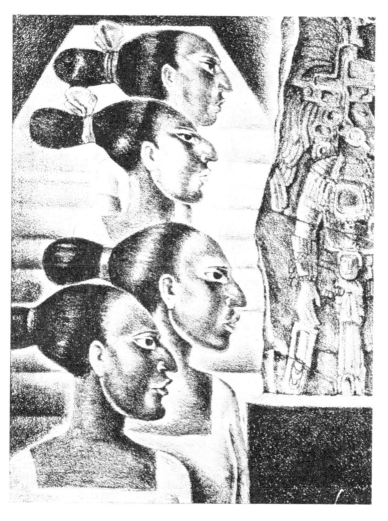

**ROBERTO MONTENEGRO**
Mayan Profiles (Lithograph, 1935), Mexican Art Gallery, Mexico City

[159]

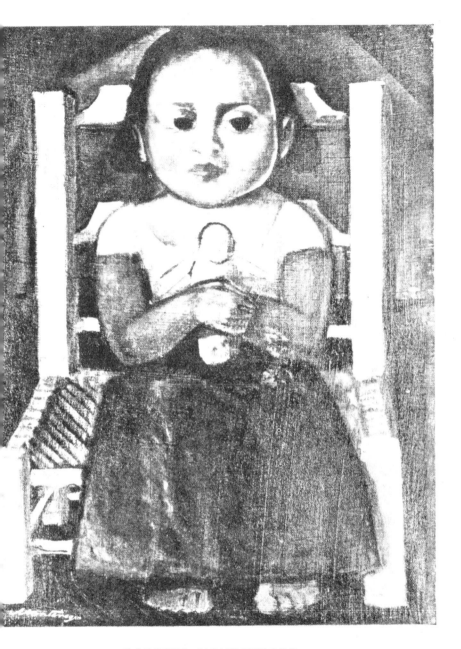

ROBERTO MONTENEGRO

Little Girl (Oil, 1932), Mexican Art Gallery, Mexico City

[161]

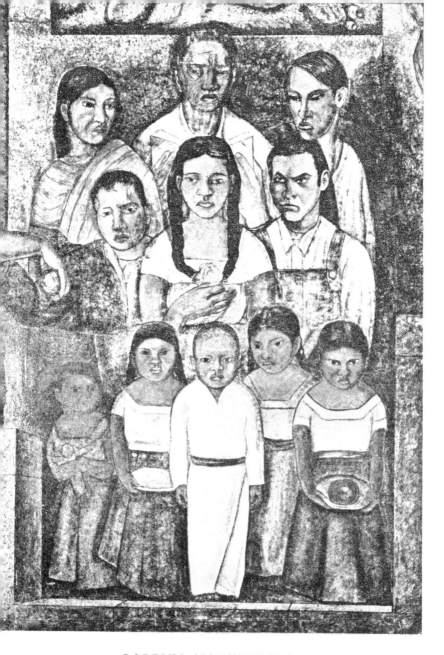

ROBERTO MONTENEGRO

The Family (Fresco, 1926), Old Monastery of Peter and Paul, Mexico City

[163]

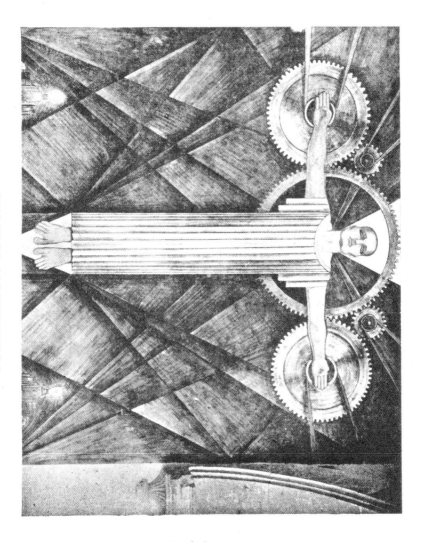

ROBERTO MONTENEGRO

Machinism (Fresco 1938) Secondary School, Mexico City

# OSE CLEMENTE OROZCO
## 3orn Zapotlan, Jalisco, 1883

T WAS Dr. Hans Tietze who, in a monograph published in Vienna Albertina Museum, 1933), wrote of Orozco: "This Mexican art s the most direct evidence of an old power of the soil." Nothing nore just can be said about this painter, who is undoubtedly one of he most distinguished artists Mexico has produced.

He was graduated from the National School of Agriculture in Mexico City, and later studied mathematics at the National University of Mexico, and architectural drawing at the Academy of ine Arts. For some time thereafter he worked as an architect's draughtsman. In 1913, he painted a canvas of great dimensions in he former Museum of San Juan de Ulua, in which he depicted the etreat of the Spanish Army in 1822. About the same time he ublished in several magazines some caricatures which strike the ye at once with their originality, vigor and ferocity. Then, in 915, Orozco presented his first exhibition in Mexico City. The ollowing period included two years of travel in California. In 1922, Orozco joined the Painters' Syndicate and was appointed to decorate the National Preparatory School. At this time he also painted a mural in "The House of Tiles" (Sanborns'), that elicited high raise from the critics of the day. A little later he was appointed to decorate the Industrial School of Orizaba, where he surpassed his earlier work, painting with great purity of expression and emoional content. After the Painters' Syndicate dissolved, Orozco continued his work at the Preparatory School and finished the frescoes e had been commissioned to paint. In 1927, he went to the Jnited States where several exhibitions of his works were held. rom 1927 to 1934 he painted fresco murals at Pomona College, Claremont, California, at the New School for Social Research in

New York City, and in Baker Library at Dartmouth College.

An exhibition of the greater part of Orozco's work, assembled and arranged by Mrs. Alma Reed, director of the Delphic Studios, was held in April, 1934, in the civic auditorium of La Porte, Indiana. This included lithographs, mural studies, paintings, drawings, and photographs of his frescoes in Mexico and in the United States. It definitely established Orozco as one of the greatest painters in America.

He made his first trip to Europe in 1932, returning to the United States that same year. In August, 1934, he went back to Mexico City where he decorated one of the wings of the great hall of the Palace of Fine Arts. In his development of the theme "War" Orozco utilizes new and vigorous methods of expression, and in this mural, reveals a versatility of pictorial conception and a plastic development indicative of greatness. Antonio Castro Leal, then head of the Department of Fine Arts, who designated Orozco for the task, has said: "If there are other Mexican painters who have succeeded in portraying with art and vigor the revolutionary ideas of present Mexico, it is unquestionable that no one has expressed as Orozco, the eternal, tragical and human aspect of our civil and social struggles."

A collection of Orozco lithographs presented by the Mexican Art Gallery in 1935, made evident the preoccupation of this artist with the development of a technique parallel in its significance to the guiding ideal.

In 1936, Orozco went to Guadalajara, Jalisco, where, al fresco, he decorated the University of the same city. Of these decorations Guillermo Rivas has said: "In his newer symbolism, Orozco resorts less to abstraction and more to objectivity; while his present theme is that of a purely materialistic concept of the past, present and future of mankind, the pictorial values of his art confirm the grandeur and eternal qualities that animate it."

[168]

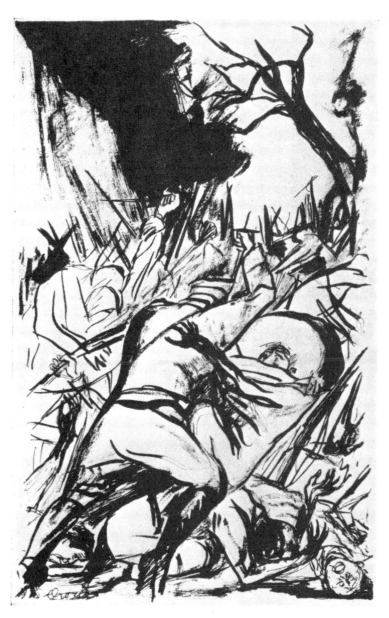

JOSE CLEMENTE OROZCO

War Slaughter (Ink, 1929), Delphic Studios, New York City

[169]

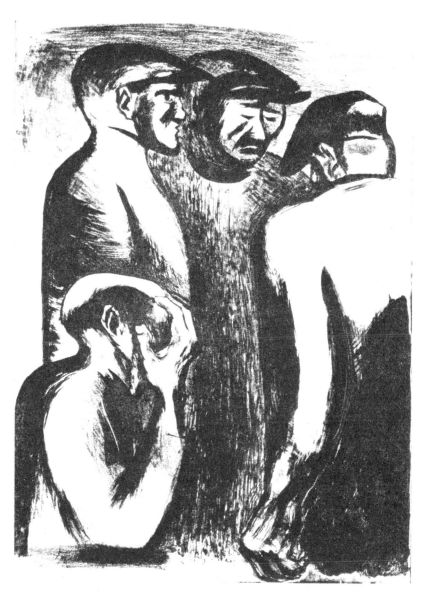

JOSE CLEMENTE OROZCO

Out of Work (Lithograph, 1932), Mexican Art Gallery, Mexico City

[171]

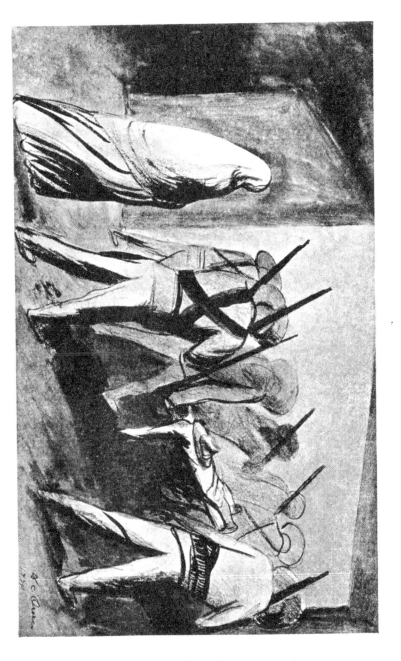

JOSE CLEMENTE OROZCO

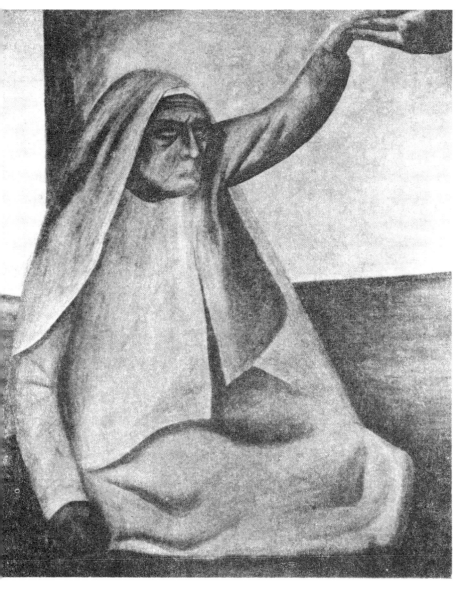

JOSE CLEMENTE OROZCO

he Farewell — *detail* (Fresco, 1926), National Preparatory School, Mexico City

[175]

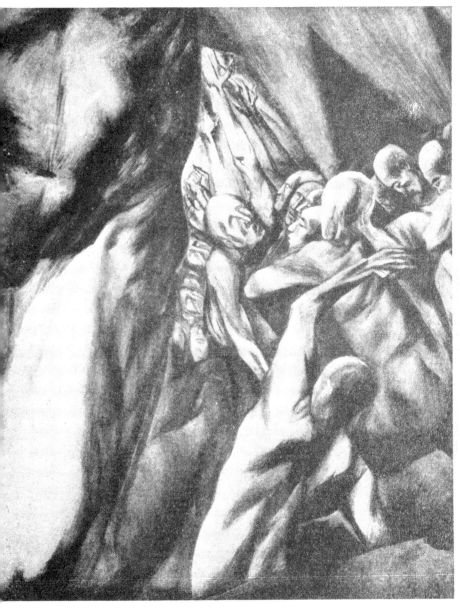

JOSE CLEMENTE OROZCO

Prometheus — *detail* (Fresco, 1931), Pomona College, Claremont, California

[177]

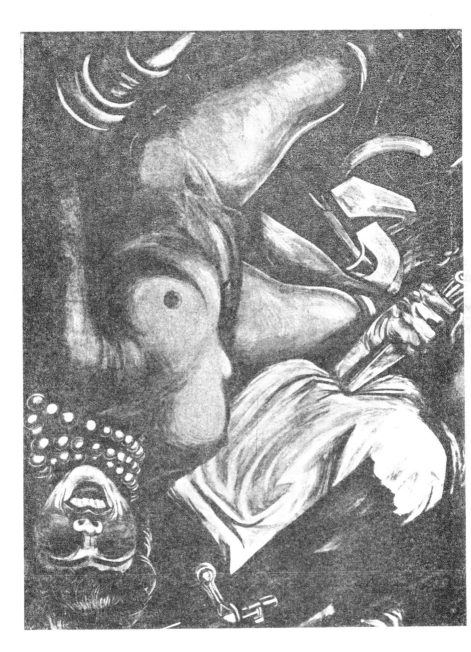

# CARLOS OROZCO ROMERO
## Born Guadalajara, Jalisco, 1898

VIGOROUS, precise and bold strokes of the brush; pale and delicate coloring, favoring green, yellow, ochre and sienna tints — these characterize Orozco Romero. An engraver, a caricaturist and a portrait painter, with a definite technique of his own, he is an outstanding example of the modern trend.

He began his artistic career in 1918 as a caricaturist for several papers in Mexico and abroad *(El Universal, Excelsior, Revista de Revistas, The Nation, The Art Center Bulletin)*. In Guadalajara he joined the group of revolutionary painters organized by Siqueiros and De la Cueva, and having been granted a scholarship by his native state, he traveled in 1921 through Spain and France and presented an exhibition of his work in the "Winter Salon" in Madrid. Upon his return to Mexico, he painted the vestibule of the Public Library at Guadalajara, and from 1924 to 1928, presented several exhibitions of his own, and participated in others with groups of fellow artists.

Together with Carlos Mérida, he organized in 1928 the Gallery of Mexican Modern Art under the patronage of the General Directorship of Civic Activities. About the same time he had an exhibition of his paintings in New York City, in Wilmington at the Society of Fine Arts," and in Chicago, at the Art Institute. The American Federation of Arts, the College Arts Association, and the Mexican Art Gallery have included him in their traveling exhibitions.

He has worked as a teacher of painting and drawing in different schools in Mexico City and as a class inspector for plastic arts in the Ministry of Public Education. In collaboration with Carlos Mérida he has published several pamphlets on the work of various

Mexican painters of colonial times, and on our present art movement, transforming a work of propaganda into one of cultural value.

Anita Brenner has said: "His work is not local, not even national; all of us understand it easily, for it is fundamental."

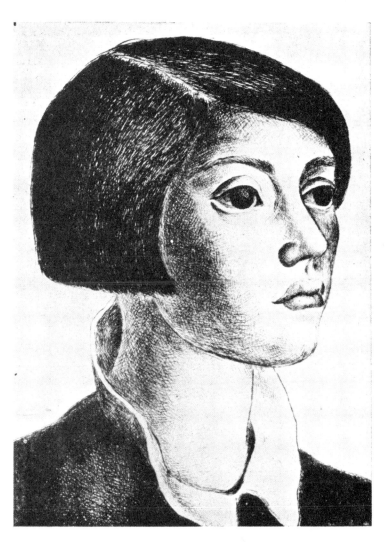

CARLOS OROZCO ROMERO
Portrait of a Girl (Drypoint, 1935), Mexican Art Gallery, Mexico City

[183]

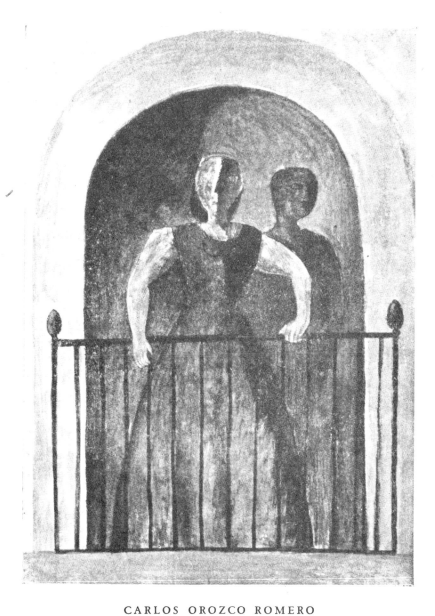

CARLOS OROZCO ROMERO
The Lady of the Balcony (Watercolor, 1932), Courtesy Mexican Art Gallery,
Mexico City

[185]

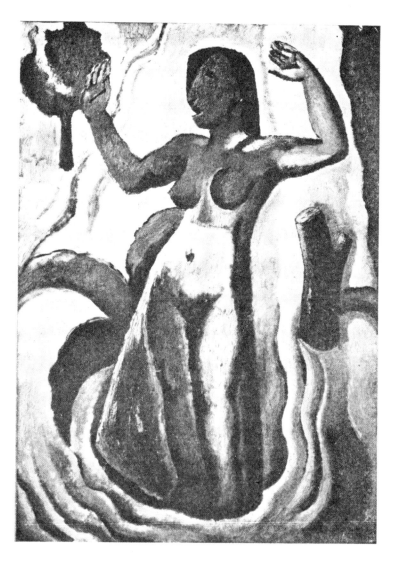

CARLOS OROZCO ROMERO
Bathing Woman (Oil, 1929), Private Collection, Mexico City

# MAXIMO PACHECO
## Born Huichiapam, Hidalgo, 1907

PACHECO is the Indian genius of contemporary Mexican painting. The humility of his work, its sincerity and its emotion, are typical of the Indian talent. He maintains, pure and undefiled, the creative spirit of his race and is the faithful interpreter of its present life. His color, forms and sentiments are the revelation of the Mexican soil turned into painting. The sorrow, the bitterness of his figures, and their attitudes of protest, result from the misery of the Indians. The gray lights, the somber tones and gloomy coloring reflect the real life of millions of Indians.

From the small peasant village where he was born, he came to the city of Mexico. There, from 1921 to 1926, he worked with Fermin Revueltas and Diego Rivera. His ability and devotion to his art soon won a place for him in the Syndicate of Painters.

From 1927 to 1934 he painted the frescoes in the library of Dr. José Manuel Puig Cassauranc, in the Cuauhtemoc School of San Joaquín Colony and in the Plutarco Elías Calles Primary School at Portales. Using encaustic painting, he decorated the Vasco de Quiroga Night Center at Atzcapotzalco, and the Industrial School at Jiquilpam, Michoacán. All these paintings reveal the artist not as one whose art is an isolated activity, of momentary and casual nature in the midst of his daily life, but rather as a human being who puts his soul and feeling into all his work with the same intensity.

He had his first exhibit in Mexico City in 1926; and participated later in exhibitions organized by the American Federation of Arts, the College Arts Association, and the Mexican Art Gallery in the United States. In the years 1931–36, he gained several first prizes in contests for poster designs.

[189]

His latest works have all the truth and emotion awakened in him by the subjects akin to his nature. In the sincerity of his painting there is to be read a vehement racial protest against poverty, exploitation, and suffering. His Indian mind has set out to denounce the cruelty and confusion of the present civilization.

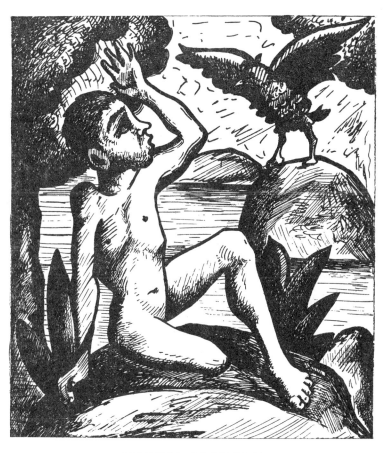

MAXIMO PACHECO

e Ugly Bird (Ink, 1930), Collection Agustín Velázquez Chávez, Mexico City

[191]

MAXIMO PACHECO

The Blaze (Tempera 1923). Night Workers' Center, Atzcapotzalco, Mexico

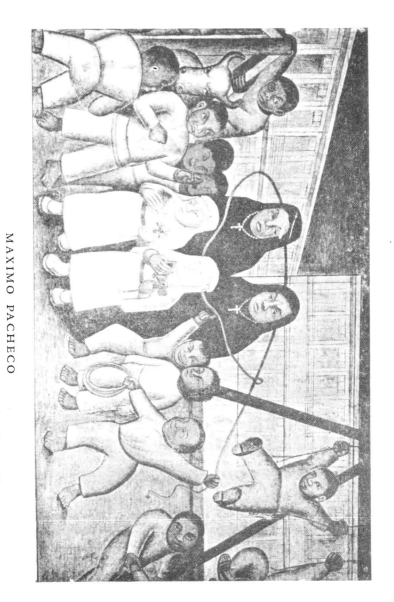

MAXIMO PACHECO

The Lasso (Fresco, 1934), Portales Primary School, Mexico City

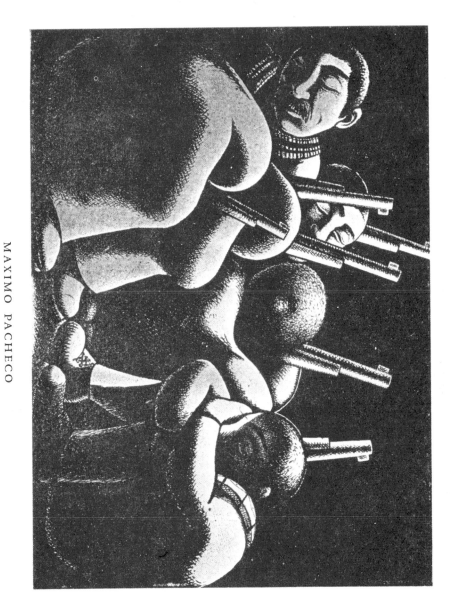

# JOSE GUADALUPE POSADA
## Born Aguascalientes, 1851
## Died Mexico City, 1913

JOSE GUADALUPE POSADA represents the first independent movement in the evolution of Mexican pictorial art; he is the first vigorous artist to draw his inspiration from our social issues. The tendency to the "popular" as well as to the "national" in our present mural painting has its beginning in Posada's engravings. Because he must be considered as one of the precursors of Mexican contemporary painting, we include him here.

He first worked in León, Guanajuato, as the principal of a school (1873). In 1877 he came to Mexico City, where he opened an engraving shop as an employee of Vanegas Arroyo, for whom, according to this publisher himself, he produced almost fifteen thousand engravings. Diego Rivera has noticed in his engravings that "Posada, as great as Goya or Callot, was a creator of inexhaustible wealth and the interpreter of the sufferings, the joy and the anguishing inspiration of the Mexican people."

He illustrated many opposition newspapers that fought the dictatorship of Porfirio Díaz; among these, *Argos, La Patria, El Ahuizote* and *El Hijo del Ahuizote*. In these, "he cut into the metal with corrosive acid to hurl the sharpest attacks at the oppressors." Besides this, he produced a great number of engravings to illustrate tales, songs, prayers, short poems, popular ballads and hand bills, setting forth in verse as well as in prose all kinds of events, crimes and anecdotes that moved and thrilled our people on account of their grandeur, eloquence, mystery, monstrousness, phantasy or humor. In all these productions Posada interpreted the sentiments of the people and their emotions. Possessing, as few artists do, a knowledge of the true nature and aspirations of popular

[199]

life, he was able to pour into his work the emotional content necessary to give it an imperishable, social and artistic value.

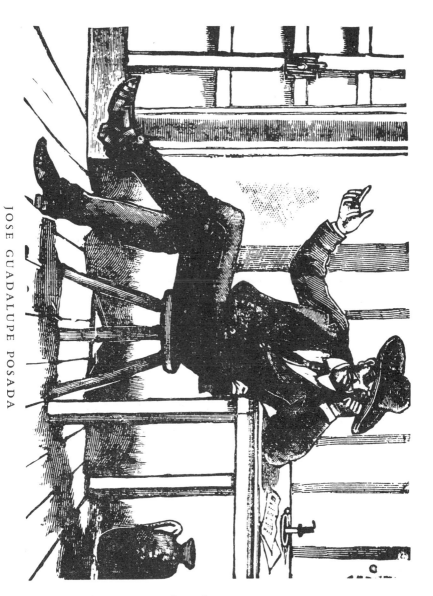

JOSE GUADALUPE POSADA

Ballad of Bruno Martínez (Woodcut, 1906), Collection Agustín Velázquez Chávez,

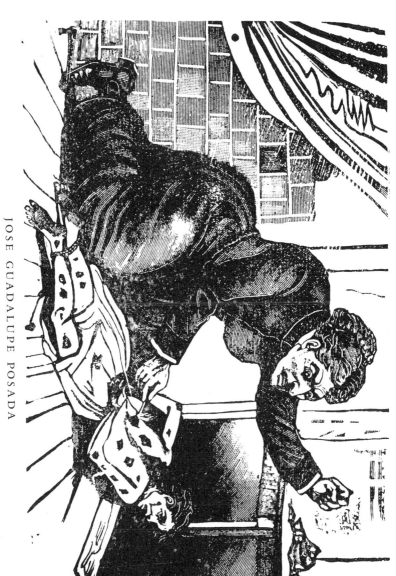

JOSE GUADALUPE POSADA
The Horrors of the Bejarano Woman (Woodcut, 1908), Courtesy Mexican Art
Editions, Mexico City

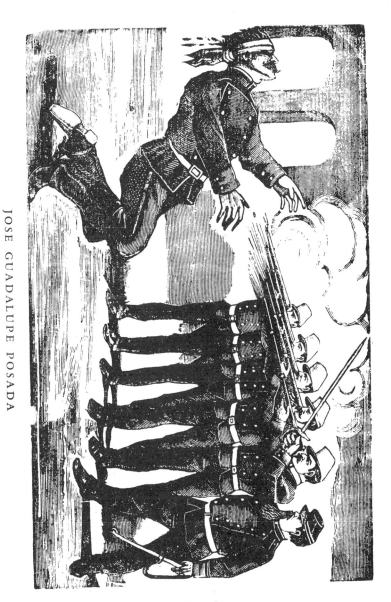

JOSE GUADALUPE POSADA

Execution (Woodcut, 1908), Collection Agustín Velázquez Chávez, Mexico City

JOSE GUADALUPE POSADA

Zapata Halloween (Woodcut, 1912), Collection Agustín Velázquez Chávez,
Mexico City

[209]

# FERMIN REVUELTAS
## Born Santiago, Papasquiaro, Durango, 1903. Died Mexico City, 1935

ALONG with Leopoldo Méndez, Revueltas joined the group of painters of the Chimalixtac School. In 1922, as a member of the Painters' Syndicate, he began his first mural decorations at the National Preparatory School, where he painted at the main entrance (Calle de San Ildefonso), in encaustic, a decoration which reveals his mastery of color.

Revueltas painted, al fresco, in the Technical Industrial Institute (1927); he did several friezes in the newspaper building of *El Nacional Revolucionario,* and a wall within the hall of the Banco Nacional Hipotecario Urbano y de Obras Publicas, as well as the library of the *Quinta Erendira* in Patzcuaro, Michoacan. In all these works he achieved compositions full of variety and imagination, and strikingly brilliant in coloring.

He designed a mural for the Railroad Men's School, the stained-glass windows of the Revolution School Center, and the interior frescoes of the monument to General Alvaro Obregón.

For several years he taught plastic arts in the primary schools of the city of Mexico, and collaborated as an illustrator of the magazine *Crisol,* in which a great number of his drawings were published.

He exhibited canvases and watercolors several times in Mexico, and in the United States he participated in exhibits organized by the American Federation of Arts and the College Arts Association.

Carlos Mérida has said of him: "His painting of vast horizons, is distinguished by his passionate impulse. A happy cry, high and clear, tinged with that somewhat romantic gravity of his eloquence. His themes, arising from an immediate reality, are un-

folded in great compositions of special broadness. His color is harmonious, and ever rich in warm shades. Revueltas' personality stands as a contrast with that of other painters of his generation who form the vanguard of modern Mexican painting."

FERMIN REVUELTAS

The River (Watercolor, 1931), Courtesy Mexican Art Gallery, Mexico City

[213]

FERMIN REVUELTAS

Progress — *detail* (Fresco, 1933), National Bank of Public Works, Mexico City

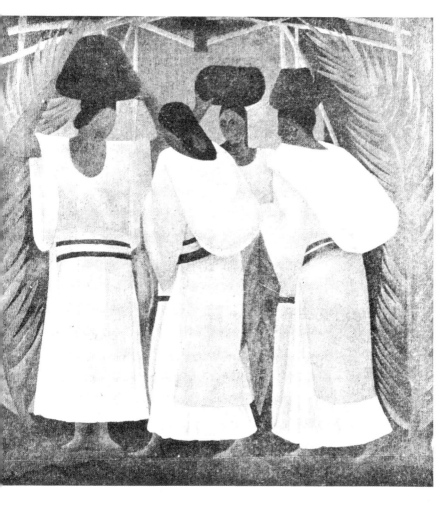

FERMIN REVUELTAS

omen from Yucatan (Oil, 1932), Courtesy Mexican Art Gallery, Mexico City

[219]

# DIEGO RIVERA
## Born Guanajuato, 1886

DIEGO RIVERA is not only the most outstanding of contemporary Mexican painters, an artist of unequaled vastness of conception; he is also the most prolific.

As a boy he studied in the San Carlos Academy and in the shop of Félix Parra. In 1907 he went to Spain, where he studied under Eduardo Chicharro, then director of the Spanish Academy of Painting. Later he traveled through Europe at the time when Dérain, Klèe, Bracque, Cézanne, and Picasso were winning wide attention with their new painting and their plastic experiments. The influence of these painters touched Rivera deeply, and he began to copy the works produced by them at that time. Later this influence was to be noticed in Rivera's own work.

Upon the triumph of the Revolution, he returned to Mexico and joined other artists in forming the Painters' Syndicate. Soon he distinguished himself as the leader in mural painting, giving this art the characteristics and aims that it has had up to the present.

In Mexico he has painted, by encaustic, the Bolivar Amphiteatre in the National Preparatory School, which marks the beginning of his mural painting. From 1922 to 1929 he painted, al fresco, the two spacious open courts of the Ministry of Public Education, the stairway of the Agricultural School at Chapingo, and the former chapel — now a part of the school — where his work shows, perhaps, greatest unity and inspiration. From 1930 to 1936 he decorated the back corridor of the Government Palace at Cuernavaca; a wing of the great hall within the Palace of Fine Arts (a work to which he was appointed by Antonio Castro Leal), wherein he reproduced the fresco begun in Rockefeller Center in

New York; the monumental stairway in the National Palace where, on a vast scale he depicts the history of Mexico, its social and economic struggles, and its "future ideal"; as well as the great hall of the Hotel Reforma, where his mastery of fresco painting finds, after fifteen years of continuous work, a confirmation of its versatility.

In the United States, Rivera has painted a great number of drawings and canvases: the frescoes in the Stock Exchange and the School of Fine Arts in San Francisco, the Detroit Institute of Arts and the New Workers' School of the city of New York.

In December 1931, the Museum of Modern Art of New York City presented a notable exhibition of Rivera's works which, like the earlier one held in the Palace of the Legion of Honor at San Francisco (1930), helped to establish him as one of the most outstanding painters of this century.

Diego Rivera stands as the example of a painter who, having assimilated and utilized a great wealth of pictorial experience, from the forerunners of Raphael up to Picasso, creates a style, personal and strong, by which he refreshes ancient wisdom with new ideas and new methods.

His work, deeply rooted in our life and culture, has disclosed an art, a life ideal, an image of beauty, drawn from the Mexican land.

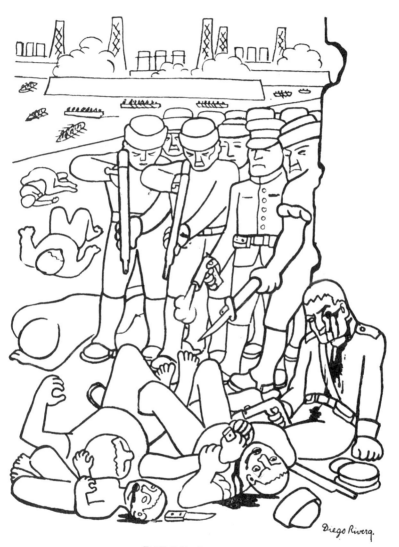

DIEGO RIVERA

ankee Invaders (Ink, 1926), Collection Agustín Velázquez Chávez, Mexico City

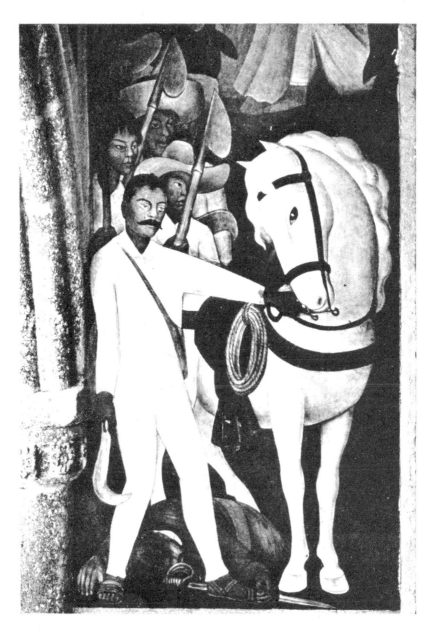

DIEGO RIVERA

The Leader of the Mexican People (Lithograph, 1932), Weyhe Gallery,
New York City

[225]

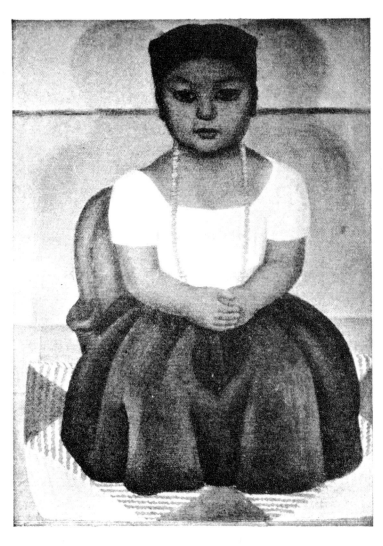

**DIEGO RIVERA**

Little Indian Girl (Encaustic, 1927), Collection Carlos Obregón Santacilia, Mexico City

[227]

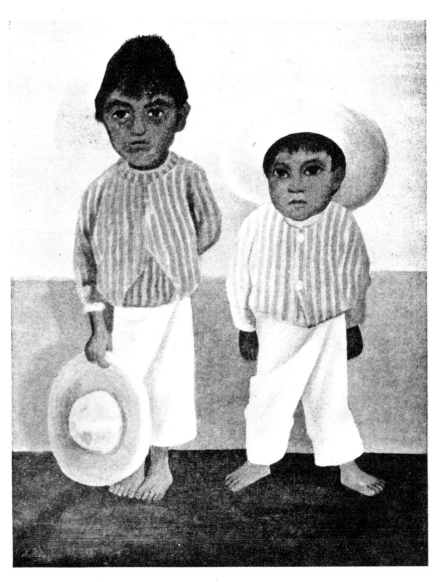

DIEGO RIVERA
Two Indian Boys (Oil, 1930), Weyhe Gallery, New York City

[229]

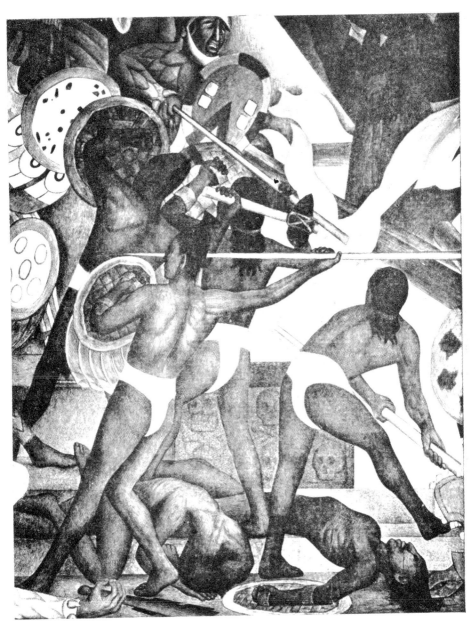

**DIEGO RIVERA**

The Conquest of Mexico — *detail* (Fresco, 1933), National Palace, Mexico City

[231]

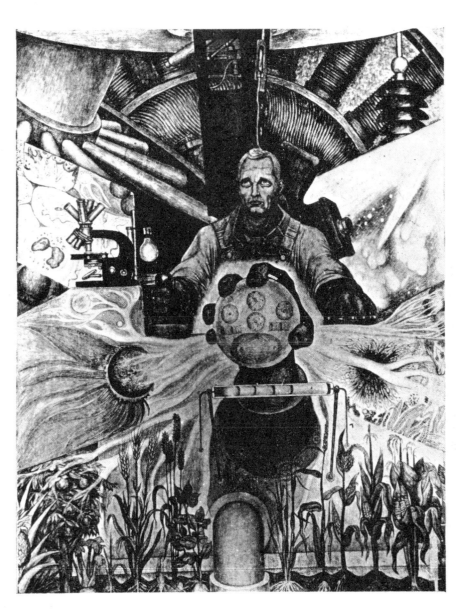

DIEGO RIVERA
Man – *detail* (Fresco, 1934), Palace of Fine Arts, Mexico City

[233]

# MANUEL RODRIGUEZ LOZANO
## Born Mexico City, 1896

FOR a long time this artist has lived in Europe. In Paris, New York, Buenos Aires and La Plata, he has presented several exhibitions praised by such critics as Salmon, Prebisch, Warnod and Henriquez Urueña.

In Mexican Art he represents at present a current separated by its tendencies and aims from that of the majority of the painters. His painting has no political content nor does he reveal any definite social tendency. Like Goitia, his asceticism isolates him; although on several occasions (1922–29), he has taken an important part in the development of pictorial art in Mexico, having formed a school of young painters in which Abraham Angel and Julio Castellanos commenced their work. He has been, during those periods, the most outstanding representative of the "purist" movement of Mexico.

In 1933 he painted sixteen panels in the home of Don Francisco Sergio Iturbe, constituting one sole decoration wherein the constant theme is death. The colors in these panels are subdued — brown, rose and blue. The human figures in their attitudes and gestures speak of the pain of life, its beginning and end, and the emotions of the human spirit in the presence of death. There is symbolism in the deserted rooms, and symbolism in the compositions and forms: the horizontal line, death, in conflict with the vertical line, life.

The pale colorings of Rodriguez Lozano, the absence of light in the forms, the ecstatic attitudes of his figures, the vagueness of his movements, the excessive refinement of color, the seeking for the unique line and form, denote extraordinary pictorial ability overflowing in the finest expression.

[235]

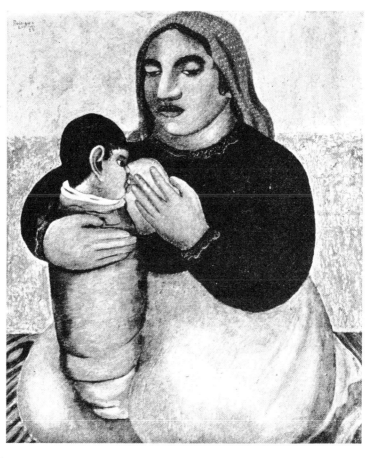

MANUEL RODRIGUEZ LOZANO
Motherhood (Oil, 1927), Weyhe Gallery, New York City

[237]

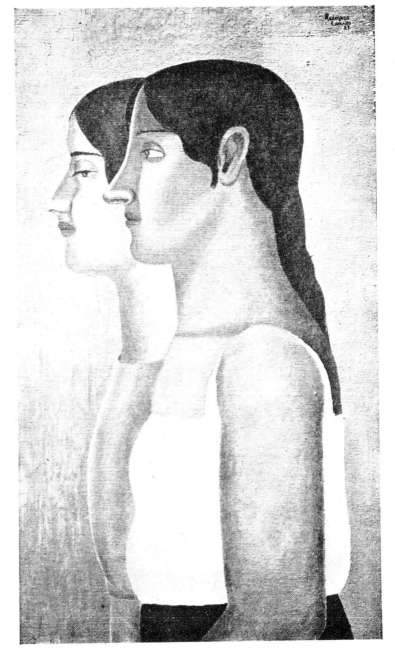

MANUEL RODRIGUEZ LOZANO

Profiles (Oil, 1929), Francisco Sergio Iturbe Gallery, Mexico City

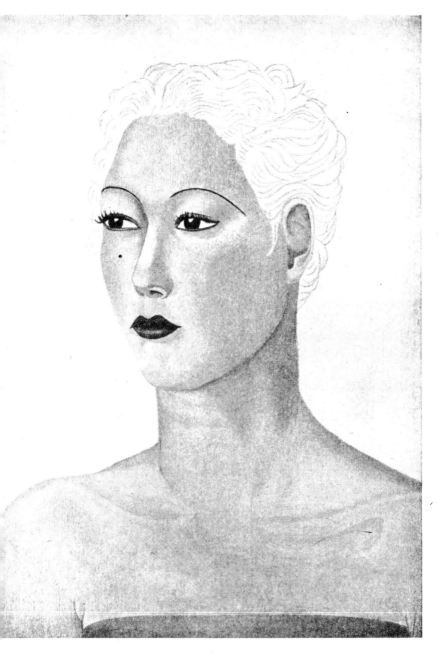

MANUEL RODRIGUEZ LOZANO

rait of Consuelo (Oil, 1932), Francisco Sergio Iturbe Gallery, Mexico City

# ANTONIO RUIZ
## Born Mexico City, 1897

THE painting of Antonio Ruiz has the liveliness and gracefulness of Mexican color with a mature and concise severity of form. His pictorial gaiety, almost childlike, is evident in all his varied themes and in the variety of qualities and attitudes of his characters. He is at times anachronistic. Girls jumping, women bathing and playing ball, are characteristic subjects. His latest productions are marked by diluted brush strokes, contrasting tones, faint shadows.

Ruiz studied at the School of Fine Arts in Mexico City. He has exhibited his work in New York and in other cities of the United States (Chicago, Boston, Hollywood), as well as in Europe (Paris, Brussels).

In 1927, the magazine *Forma* published a collection of his drawings on Mexican Architecture of the seventeenth and eighteenth century. Of these drawings it was said: "They reveal knowledge, observation and study of Mexican architecture. They are not made from a constructive standpoint. They do not obey the study of any given plan. They are spontaneous manifestations in which the play of forms is stamped with the characteristic plastic proportions of Mexican colonial style. The drawing of Ruiz, his clear intuition, and an absolute "familiarity" with the proportions of the various elements, save these compositions definitely."

Carried away by his imagination and phantasy he has designed a number of sets for the theater and cinema. With Julio Castellanos, he painted the decorations for the production of Eugene O'Neill's drama, *Different,* presented for the first time in Mexico in 1934 in the Palace of Fine Arts, then under the direction of Antonio Castro Leal.

[243]

At thirty-nine years of age, happy, like his own paintings, Antonio Ruiz asserts that he has made "imaginary trips all over the world, real trips to different parts of America." For appraisal of his work, he says that he counts not only on friends and admirers but on "the veiled and venial criticism of his enemies."

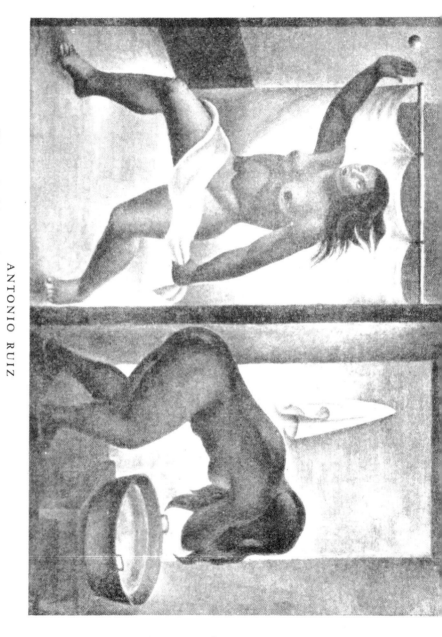

ANTONIO RUIZ

Women Bathing (Oil, 1934), Mexican Art Gallery, Mexico City

[245]

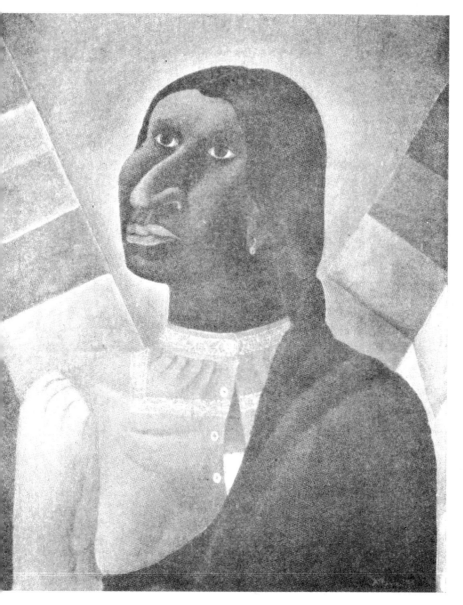

ANTONIO RUIZ

ian from Tenantzingo (Oil, 1931), Courtesy Mexican Art Gallery, Mexico City

[247]

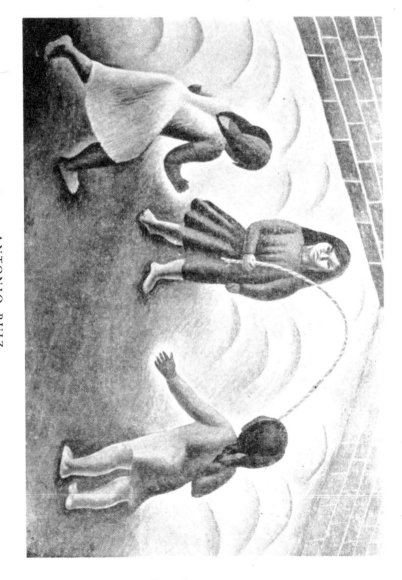

ANTONIO RUIZ

Children at Play (Oil, 1934), Mexican Art Gallery, Mexico City

[249]

# DAVID ALFARO SIQUEIROS
## Born Chihuahua, 1898

SIQUEIROS came to Mexico City very young and entered the Academy of Fine Arts. After the students' strike at the academy in 1911 he studied in the first Open Air Painting School. In 1913 he joined the forces commanded by General Diéguez and took part in the campaigns of the Western Division.

In 1919 he left for Europe, and met Rivera in Paris. He then traveled through Italy and Belgium. In Spain he published *Vida Americana,* in which the "Manifesto to the Painters of America" appeared. In Argenteuil he secured work as a draughtsman.

When he returned to Mexico in 1922 he painted, al fresco, part of the stairway of the Colegio Chico, within the National Preparatory School. At this time he was elected secretary general of the Painters' Syndicate, in which, with the cooperation of Javier Guerrero and Rivera, he published its newspaper, *El Machete.*

After the dissolution of this organization in 1924, he devoted his energies to the workers' movement. In 1925 he organized in Guadalajara, along with De la Cueva, the Alliance of Paint Workers. He established the Jalisco Mining Federation and published an anti-clerical paper called *El 130.* He joined the Confederacion Unitaria de Mexico, and with graphic and literary material produced by workers themselves, he published another magazine, *El Martillo* ("The Hammer").

He has attended international syndicalist and communist congresses held in Moscow, Montevideo, Buenos Aires and New York. On the First of May parade in 1930, he was arrested and confined to the penitentiary. The following year, with the city of Taxco as his prison, he painted a large number of canvases, and did also quite a number of lithographs and woodcuts. Eisenstein

and Hart Crane, at that time in Mexico, patronized an exhibition of these works. Later he went to Los Angeles to work with block of American painters with whom he painted exterior frescoe on public buildings, using mechanical means (the Chouinar School of Art, and the Plaza Art Center). He also decorated a co: ridor in the home of Dudley Murphy, a moving-picture directo: The political ideas expressed through this painting caused h expulsion from America.

In 1932 he went to Montevideo and Buenos Aires, where h lectured and opened a number of exhibitions of his own work. I Buenos Aires, with Spilimbergo, Berni, Lazaro and Castanino, h painted, al fresco, an extraordinary and advanced decoration calle "Plastic Study." Using mechanical instruments, he painted walls floor and ceiling, attempting to develop a dynamic geometrica composition with architectural qualities. This painting gives th impression of fantastic and wicked movement. It storms th consciousness, suggesting unlimited depths of sensation.

In 1934 he went to Brazil and gave a series of lectures. He the went to New York, where he held an exhibition in the Delphi Studios, and returned that same year to Mexico.

Ruiz' restless activity is often expended on problems pertainin to contemporary Mexican revolutionary art. He launches crit cisms against Mexican mural painting at the beginning of th present art movement. He speaks on the course of revolutionar art and on plastic strategy. In three lectures in February, 1935, h expounded his theories regarding "monumental painting." Afte the excitement they aroused, he used Duco paint as a medium fc the first time in the history of Mexican art. The results of thi work were shown at the Mexican Art Gallery in July, 1935. It force of expression, its magnificent resources for fantasy and it chromatic versatility unveiled to Siqueiros the path in which hi artistic effort is now concentrated.

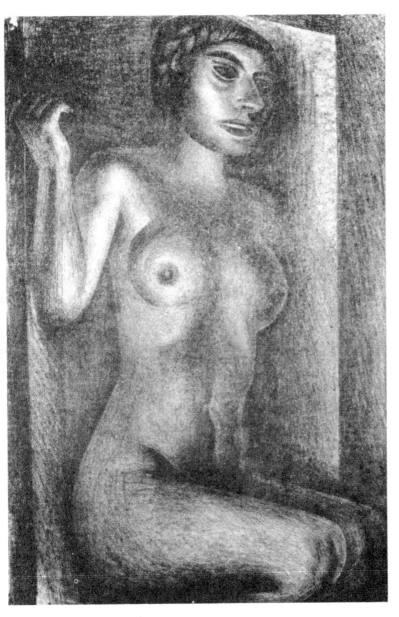

DAVID ALFARO SIQUEIROS

Nude (Lithograph, 1932), Weyhe Gallery, New York City

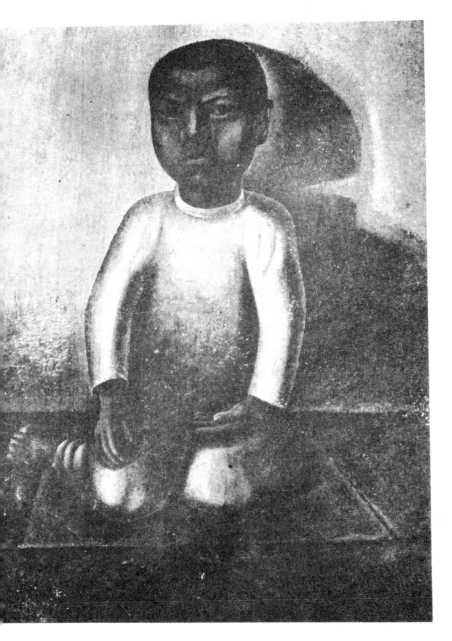

DAVID ALFARO SIQUEIROS

Indian Boy (Encaustic, 1929), Courtesy Mexican Art Gallery, Mexico City

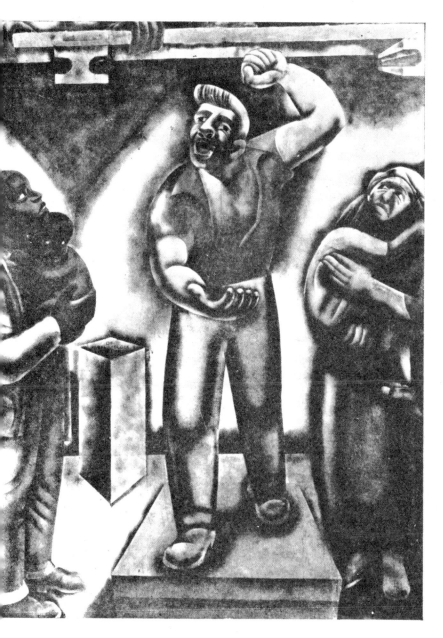

DAVID ALFARO SIQUEIROS

he Struggle — *detail* (Fresco, 1932), Chouinard School of Art, Los Angeles,
California

[257]

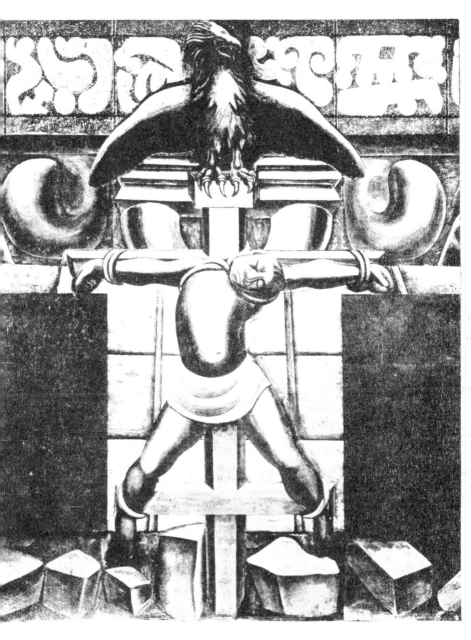

DAVID ALFARO SIQUEIROS
The Tropical Race — *detail* (Fresco, 1932), Plaza Arts Center, Los Angeles,
California

[259]

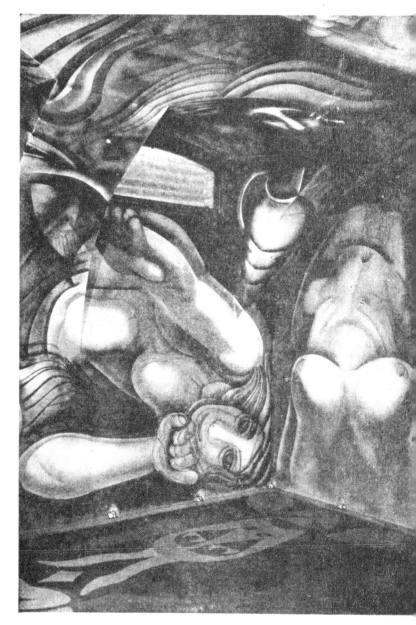

DAVID ALFARO SIQUEIROS

Plastic Study — detail (Fresco, 1933), Private Building, Buenos Aires, Argentina

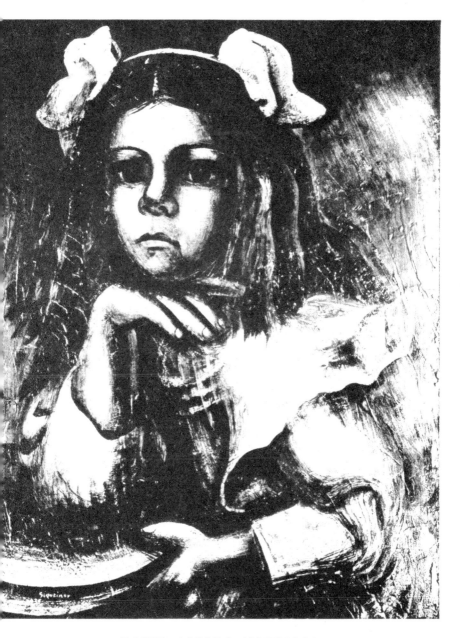

DAVID ALFARO SIQUEIROS
Portrait of a Girl (Duco, 1935), Mexican Art Gallery, Mexico City

[263]

# RUFINO TAMAYO
## Born Oaxaca, 1899

TAMAYO began his studies at the National School of Fine Arts in the city of Mexico, but he remained there only a short time. Discontented with official art teaching, he decided to study alone, and endeavored to acquaint himself with the different trends in painting which existed at that time.

As a "solitary rebel," he was against the "Mexicanist" tendency then adopted by several painters who indulged, according to Tamayo, in the "picturesque." He considered that they neglected the true problems of painting. His artistic ideas found an echo among other Mexican artists of that time, and with them he started a movement intended to give painting greater pictorial purity without loss of local color.

In 1926 he presented an exhibit which marked the beginning of his career. Later he made two trips to the United States, where he took part in group exhibitions held in New York (Art Center, 1927; Weyhe Gallery, 1928).

Upon his return to Mexico he carried on the ideas which he had proclaimed, and organized and took part in a number of group exhibits. He studiously sought for universal principles, and worked for unity and purity of expression, with the purpose of giving a modern interpretation to the life around him. The productions of those years became on the whole more transparent and mundane, but he tended at times to lapse into still life and abstractions.

He was at this time a teacher of plastic arts in the primary schools of the city of Mexico. Later he became head of the plastic arts section in the Ministry of Public Education and assembled an interesting collection of paintings done by children in the primary schools.

Of late, Tamayo's purpose to give painting a more solid objective foundation becomes more and more clear, and imparts distinctive values to his work. His design, for all his careful attention to it, is never arbitrary. There is present in it a definite intention to use color in relation to the arrangement of masses, and to maintain a harmony between subject, color and form. Through these means, he is able to give dramatic emphasis and human significance to the themes of his pictures. These themes, while they are in no sense popular or national, do reveal certain aspects of Mexican life that savor of the moods and feelings of the people.

These characteristics of his art were already developed in 1933 when he decorated, al fresco, the stairway of the National Conservatory of Music. There he developed, as a pictorial theme, music and its component elements. The frescoes are a clear expression of his capacity to impart plastic values to abstract elements, a rare trait in present mural painting in Mexico.

In 1935 a complete exhibition of Tamayo's later work was presented by the Mexican Art Gallery. It elicited great interest among critics and artists because of his refined conception of a future Mexican painting. This later work contrasted sharply with his first compositions — subjects of a strong popular savor drawn from his native state. An evolution was apparent in themes, technique and mediums of expression, while his warm nature and instinctive sensuality remained a constant factor. The path of this artist's development, his efforts to give his art greater plastic purity, were anchored in his heritage from the land of Oaxaca. The qualities which this man had expressed with an artist's emotion and intuition were the qualities of his people.

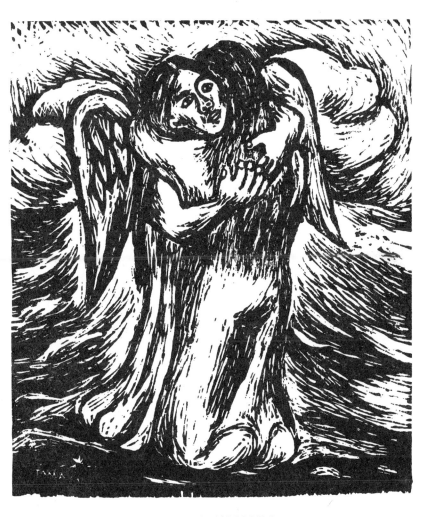

RUFINO TAMAYO

_e Angel (Woodcut, 1935), Collection Agustín Velázquez Chávez, Mexico City

[267]

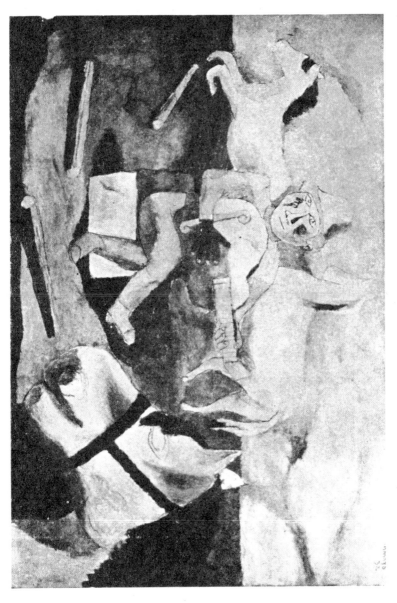

[269]

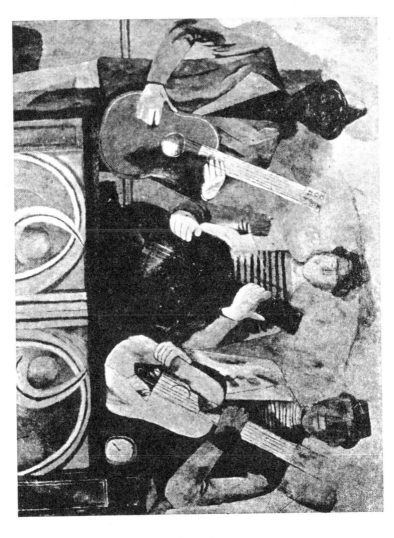

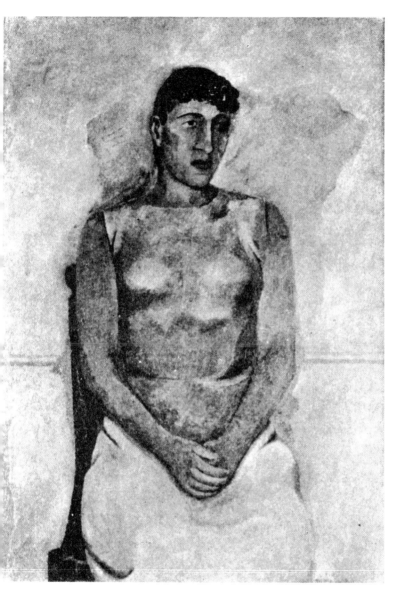

RUFINO TAMAYO
La Femme de l'Artiste (Oil, 1935), Private Collection, Mexico City

[273]

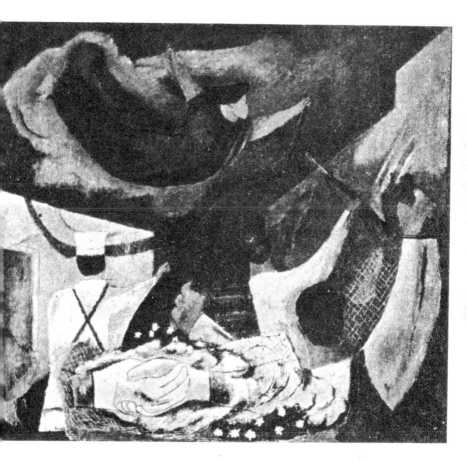

RUFINO TAMAYO

Call of the Revolution (Oil, 1935), Courtesy Mexican Art Gallery, Mexico City

[275]

# ALFREDO ZALCE
## Born Patzcuarco, Michoacan, 1908

ALFREDO ZALCE is one of the youngest and most distinguished painters of the present art movement in Mexico. For six years he studied in the Fine Arts Academy in Mexico City, where he lived as a boy.

In 1929 he was a student in the Escuela de Talla Directa ("School of Direct Carving"); and in 1931 he exhibited for the first time, participating in the exhibition of Mexican painters organized by the Art Hall of the Ministry of Public Education. The Posada Gallery included him in its fifth exhibit (1932), and the Italian Court at Chicago held an exhibition of his watercolors and drawings in October, 1934. Zalce also took part in the Exposition of Arts and Industries held in Seville, where his painting was awarded a first prize.

Along with Isabel Villaseñor, he painted the exterior of the Ayotla School, Tlaxcala, experimenting for the first time in the history of Mexican painting with colored cement. He painted, al fresco, for the Ministry of Public Education, the vestibule of the school named "Dr. Balmis" in Mexico City and, in collaboration with other painters, the stairway of the National Printing Office (1936).

In the review *Contemporaneos,* Zalce has published three lithographs illustrating a poem of Bernardo Ortíz de Montellano, and in the studio of Amero, the painter, a collection of fifteen lithographs. The magazine *Frente a Frente,* organ of the League of Revolutionary Writers and Artists, has also published some of his drawings.

He has been a teacher of drawing in the primary schools as well as in the Schools for Architects and Builders of the Ministry of

Public Education, which later employed his services as inspector of the plastic arts classes and director of the Open-Air Painting School at Taxco. His yearning to sense and acquaint himself intimately with the life of the people and with the economic and social conditions, led him out into the country in 1935, as a teacher in one of the cultural missions. Upon his return to Mexico City in 1936 he joined the League of Revolutionary Writers and Artists, and together with Leopoldo Méndez, Fernando Gamboa and Paul O'Higgins, formed a group of mural painters.

His latest works, soft and agile in design, full of rhythm and movement, playing between blues, greys, ochres and reds, are unmistakably inspired by themes from the tropical lands of Mexico. They possess the sentiment and emotion of "small great works."

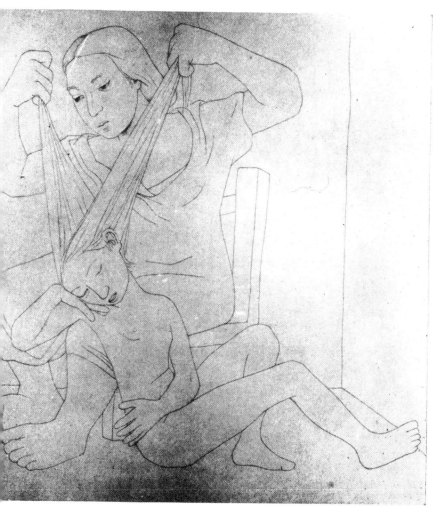

**ALFREDO ZALCE**
Mother and Child (Pencil, 1932), Private Collection, Mexico City

[279]

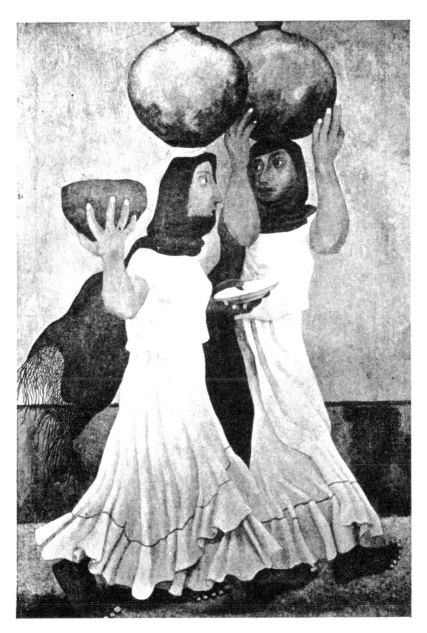

ALFREDO ŽALCE
Women From Tehuantepec (Oil, 1934), Private Collection, Mexico City

[281]

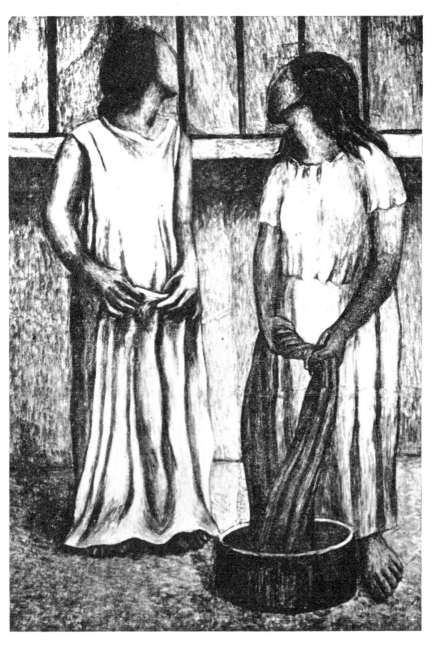

**ALFREDO ZALCE**
The Dyers (Fresco, 1933), Doctor Balmis School, Mexico City

[283]

# SELECTED BIBLIOGRAPHY
## General

ADAMS, PHILIP RHYS, "Notes on New Aspects of Mexican Art," Columbus Gallery of Fine Arts *Monthly Bulletin*. Columbus, Ohio, 1936.

ATL, DOCTOR, *Las Artes Populares en México*. II Vols. Editorial Cultura, Mexico, 1922.

ANONYMOUS, Mexican Number, *Survey Graphic*, New York, April, 1924.

———"Le Renaissance Artistique du Mexique," *Revue de l'Amerique Latine*, Paris, June, 1926.

——— *Panamerican Union Bulletin*. Washington, D. C., July, 1926.

——— *Catálogo de la Exposicion de Arquitectura y Arte Decorativo Mexicano*. Institución Hispano Cubana de Cultura, Habana, 1929.

——— Mexican Art Number. *School Arts Magazine*, New York, February, 1932.

——— *Mexican Painters Scrapbook*. New York Public Library, New York, 1932.

———"Modern Mexican Murals," *Arts and Decoration*, New York, 1934. XLI: 3, pp. 22–24.

———"La Exposición de Arte Mexicano," *Puerto Rico Ilustrado*, Rio de Piedras, February, 1935.

———"El Arte Moderno en las Americas." *Boletín de la Unión Panamericana*, Washington, D. C. March, 1935.

ARENDT, MARION LUCILE, *The Historical Significance of Mexican Art and Architecture*. S. E. P., Mexico, 1928, Publication XVIII, No. 3.

BEST MAUGARD, ADOLFO, *Método de Dibujo, Tradición y Resurgimiento del Arte Mexicano*, S. E. P. Mexico, 1923.

BIDDLE, GEORGE, "Mural Painting in America," *American Magazine of Art*, Washington, D. C., 1934. XXVII: 7. pp. 365–67.

BRENNER, ANITA, *Idols Behind Altars*. Payson & Clarke, New York, 1929.

———"A Mexican Renascence." *The Arts*, New York, 1928.

———"Painted Miracles." *The Arts*, New York, 1928.

———"Some Christian Images from the Mexican Pantheon." *The Arts*, New York, 1929.

———"Children of Revolution," *Creative Art*, New York, 1929.

———"Street Murals of Mexico," *The Arts*, New York, 1929.

BRETAL, MAXIMO, "La Nueva Pintura Mexicana Social." *Havana*, Habana, April 1927. pp. 40–62.

CASSOU, JEAN, "Le Renaissance de l'Art Mexicaine." *Art Vivant*, Paris, 1929. v 758–60.

COSSIO VILLEGAS, DANIEL, "La Pintura en México." *Cuba Contemporánea*, Habana April, 1924. pp. 331–39.

CRAVEN, THOMAS, *Men of Art*, Simon & Schuster, New York, 1931. pp. 509–11.

——— *Modern Art*, Simon & Schuster, New York, 1934. pp. 346–64.

CRESPO DE LA SERNA, JORGE JUAN, "On Mexican Art and Artists." *Catalogue of College Art Association Exhibition*, New York, 1934.

CRUMP, ELIZABETH ENDERS, "A Revival of Mexican Art," *International Studio*, New York, 1921. LXXII: 286. p. XCII.

D'HARNANCOURT, RENE, "*Mexican Arts*," *Catalogue of Exhibition, the American Federation of Arts*, New York, 1930.

——— "The Loan Exhibition of Mexican Art." *Bulletin of the Metropolitan Museum of Art*, New York, 1930. XXV: 10. pp. 210–17.

——— "An Authentic Exposition of Mexican Art," *Mexican Life*, Mexico, 1930. VI: 7.

——— "Four Hundred Years of Mexican Art," *Art and Archaeology*. New York, March, 1932.

DWYER, EILEEN, "The Mexican Modern Movement," *Studio*, London, 1927. XCIV: 262–66.

EVANS, ERNESTINE, "Frescoes Glorify Mexican Indian Life," *New York Times Magazine*. New York, September 26, 1926.

FAURE, ELIE, "La Peinture Murale Mexicaine, *Art et Medicine*, Paris, April, 1934.

GARCIA MAROTO, GABRIEL, "Arte y Artistas Mexicanos," *El Universal*, México, D. F., September 22, 1928.

GOMEZ MAILLEFERT, E., "La Peinture Mexicaine Contemporaine," *Art Vivant*. Paris, January 15, 1930.

GRUENING, ERNEST, *Mexico and Its Heritage*. New York, 1928.

HASTINGS, VISCOUNT, "Renaissance in Mexico." *Architectural Review*, Westminster, 1935. LXXVIII: 465.

HENRIQUEZ URENA, PEDRO, "Revolution and Intellectual Life," *Survey Graphic*. New York, May, 1934.

HERRING, HUBERT, *Renascent Mexico*. Covici Friede, New York, 1934.

HERRIMAN, W., *The Real Mexico*. London, 1914.

LAVACHERY, H., "La collection Mexicaine de M. A. Gennin." *Bulletin de Musees Royaux d'Art et d'Histoire*. Bruxelles, 1931. III: 35–51.

NELKEN, MARGARITA, "En Torno a la Exposición de Pintores Jovenes Mexicanos," *Arte Espanol*. Madrid, 1927. VIII: 16.

RIVAS, GUILLERMO, "The Artists Look Backwards," *Mexican Life*. Mexico, D. F., December, 1936.

——"Notes of The Carnegie Exhibit," *Mexican Life*, Mexico, D. F., 1930. VI: 8.

——"More Walls to Paint," *Mexican Life*, Mexico, D. F., 1930. VI: 12.

——"Eight Modern Mexican Painters," *Mexican Life*. Mexico, D. F., 1931. VII: 2.

ROBINSON, I., "Fresco Painting in Mexico," *California Arts and Architecture*. Los Angeles, Calif., January, 1932.

ROGERS, M. R., "Contemporary Mexican Paintings." *St. Louis Museum Bulletin*. St. Louis, January, 1936.

SALAZAR, ROSENDO, *México en Pensamiento y en Acción*. México, D. F., 1926.

SEARS, M. U., "Art of Painting in Modern Mexico," *California Arts and Architecture*. Los Angeles, Calif., October, 1931.

SHERWELL, GUILLERMO A., "Modern Tendencies in Mexican Art." *Pan American Union Bulletin*, Washington, D. C., 1922. Vol. LV.

SPRATLING, WILLIAM, "Figures in a Mexican Renascence," *Scribner's Magazine*, New York, January, 1929.

TABLADA, JOSE JUAN, *Historia del Arte en México*. Editora Aguilas, Mexico, D. F., 1927.

——"Mexican Painting of Today." *International Studio*. New York, 1923. LXXVI: 267–76.

——"The Arts in Modern Mexico," *Parnassus*, New York, 1929. Vol. I.

——"Recent Activities in Mexican Art," *Parnassus*, New York, April, 1930.

VELA, ARQUELES, *Historia Materialista del Arte*. S. E. P. México, D. F., 1936. p. 77–80.

VELAZQUEZ CHAVEZ, AGUSTIN, *Indice de la Pintura Mexicana Contemporánea*. Ediciones Arte Mexicano, Mexico, D. F., 1935.

——"Las Bellas Artes en Relacion con la Función Cultural del Estado." *Reforma Social*, Tlaxcala, December, 1934.

——"Una Exposición de Pintura Mexicana en Honolulú," *Revista de Revistas*, Mexico, D. F., August 4, 1935.

WOLFE, BERTRAM D., "Art and Revolution in Mexico," *The Nation*. New York, August, 27, 1924.

ZIGROSSER, CARL, "Mexican Graphic Art," *Print Collectors Quarterly*. London, January, 1936.

ZUNO, JOSE G., "L'Esthétique Mexicaine," *L'Art Vivant*, Paris, January 15, 1930. p. 84.

# SELECTED BIBLIOGRAPHY
## Individual

### ABRAHAM ANGEL

BRENNER, ANITA, *Idols Behind Altars*. Payson and Clarke, New York, 1929. pp. 239–317.

RODRIGUEZ LOZANO, MANUEL, "A. A." *Revista Musical*, Mexico City, November, 1928.

SYMPOSIUM. "A. A.," *Talleres Gráficos de la Nación*. México, 1924. (Black and white and color plates).

TABLADA, JOSE JUAN, *Historia del Arte en México*. Editora Aguilas, México, 1927.

### DOCTOR ATL

ANONYMOUS, "El Dr. Atl en la Galería de Arte Moderno," *Nuestra Ciudad*. Mexico City, 1930. 1: 2.

———"Quelques oeuvres de Dr. Atl," *L'Art Vivant*. Paris, 1930, No. 122.

RIVAS, GUILLERMO, "Dr. Atl, A Most Unusual Personality," *Mexican Life*. Mexico City, December, 1933.

SALAZAR, ROSENDO, *México en Pensamiento y en Acción*. Mexico, 1930.

*OWN WORKS:*

*The Mexican Revolution and the Nationalization of the Land*. Mexican Bureau of Information, New York, 1915.

*Catálogo de las Pinturas y Dibujos de la Colección Pani*. Universidad Nacional, México City, 1921.

*Las Sinfonías del Popocatepetl*. Editorial México Moderno, Mexico City, 1921.

*Las Artes Populares en México*. Editorial Cultura, Mexico City, 1922. II Vols.

*Cúpulas Mexicanas*. Publicaciones de la Secretaría de Hacienda. Mexico City, 1927.

*Le Sinfonie del Popocatepetl*. Edizione Cristofari, Milano, 1930.

*Cuentos Bárbaros*. Editorial Libros Mexicanos, Mexico City, 1930.

*Cuentos de Todos Colores*. Ediciones Botas, Mexico City, 1931.

*El Paisaje*. Mexico City, 1933.

*Five Reproductions of Mexican Landscape*. Mexico City, 1933.

*La Perspectiva Curvilínea de Luís G. Serrano.* Editorial Cultura, Mexico City, 1934.

*Un Hombre más allá del Universo.* Preface by Diego Rivera. Ediciones Botas, Mexico City, 1935.

## JULIO CASTELLANOS

ANONYMOUS, "Oleos y Dibujos de J. C." *Contemporáneos,* Mexico City, 1929. I: 9. pp. 124-29.

——"Dibujos de J. C." *Contemporáneos,* Mexico City, 1931. IV: 38-39. pp. 133-38.

BOAS, GEORGE, "The First Panamerican Art Exhibition," *The Arts,* New York, March, 1931.

CARDOZA Y ARAGON, LUIS. Julio Castellanos. *G. de P. M. M.,* Mexico City, 1933.

RIVAS, GUILLERMO, "Julio Castellanos," *Mexican Life.* Mexico City, September, 1936.

*BOOKS ILLUSTRATED:*

ORTIZ DE MONTELLANO, BERNARDO, *Red.* Mexico City, 1931.

## MIGUEL COVARRUBIAS

*OWN WORKS:*

*The Prince of Wales and Other Famous Americans.* A. Knopf, New York, 1925.

*Negro Drawings.* Preface by Frank Crowninshield. A. Knopf, New York, 1927.

*Bali.* A. Knopf, New York, 1936.

*BOOKS ILLUSTRATED:*

CHADOURNE, MARC, *Chine.* Editions Plon, Paris, 1932.

GORDON, TAYLOR, *Born to Be.* Covici, Friede, New York, 1929.

HANDY, W. C., *Blues.* C. & A. Boni, New York, 1926.

HURSTON, SORA, *Mules and Men.* Lippincott, New York, 1935.

HUSTON, JOHN, *Frankie and Johnny.* C. & A. Boni, New York, 1930.

MARAN, RENE, *Batouala,* Limited Editions Club, New York, 1932.

MELVILLE, HERMAN, *Typee.* Limited Editions Club, New York, 1935.

RIDDELL, JOHN, *Meaning No Offense.* John Day, New York, 1930.

TANNENBAUM, FRANK. *Peace by Revolution.* New York, 1933.

# FRANCISCO DIAZ DE LEON

ACEVEDO ESCOBEDO, ANTONIO, "Arte en la Esquina," *Revista de Revistas*, Mexico City, February, 1933.

ANONYMOUS, "Grabados en Madera de F. D. L." *Forma*, Mexico City, 1926. I: 2.

———"Grabados de F. D. L." *Contemporáneos*. Mexico City, 1931. III: 32.

———"Díaz de León resucita el grabado en México," *El Universal*, Mexico City, July 22, 1934.

———"Arte Mexicano," *Gaceta de Bellas Artes*. Madrid, November 15, 1934.

BELOFF, ANGELINA, "El Grabador D.L.," *Revista de Revistas*, Mexico City, June, 1934.

FARFAN CANO, ISABEL, "F. D. L." *Cronos*. Mexico City, 1933. III: 5.

GONZALEZ PENA, CARLOS, "El Grabado en México," *El Universal*, Mexico City, July 8, 1934.

SILVA Y ACEVES, MARIANO, "Las Maderas de F. D. L." *Conozca Usted a México*, Mexico City, 1924. I: 4.

## OWN WORKS:

*30 Asuntos Mexicanos*. Mexico City, 1928.

## OWN WRITINGS:

*Las Escuelas de Pintura al Aire Libre*, foreword to. S. E. P., Mexico, 1926.

*El Grabado en Madera en México. Universidad de Mexico*. Mexico City, 1933. V: 27–28.

*Un Nuevo Grabador en Madera*, foreword to. Album de Maderas Jesus Morales A.. Estado de México, 1933.

"La Influencia Romántica en la Tipografía Mexicana," *El Libro y El Pueblo*. Mexico City, June, 1934.

"Historia del Grabado en México," *El Nacional Revolucionario*, Mexico City, May-July, 1934.

"Maderas de Jesus Chávez Morado." *Revista de Revistas*. Mexico City, October, 1936.

## BOOKS ILLUSTRATED:

SILVA Y ACEVES, MARIANO, *Campanitas de Plata*. Editorial Cultura, Mexico, 1925.

TOUSSAINT, MANUEL, *Oaxaca*, Editorial Cultura, Mexico, 1926.

PALACIOS DE MENDEZ, LUZ, *Poemas*. Editorial Cultura, Mexico, 1929.

Padilla, Ezequiel, *En la Tribuna de la Revolución*. Editorial Cultura, Mexico 1929.

*Los Nuevos Ideales en Tamaulipas*. Editorial Cultura, Mexico, 1929.

Fernandez Ledesma, Enrique, *Viajes al Siglo XIX*. Mexico, 1933.

——— *Historia de la Tipografía en México en el Siglo XIX*. Ediciones del Palacio de Bellas Artes, Mexico, 1934.

Anonymous. *Dotación de Aguas*. Fondo de Cultura Económica Mexico City, 1935.

## FERNANDEZ LEDESMA GABRIEL

Anonymous, "Grabados en Madera de G. F. L., *Forma*, Mexico City, 1927. I: 6

———"G. F. L." *Indo-América*, Mexico City, 1928. I: 1.

———"Juguetes Mexicanos," *El Sol*, Madrid, April 22, 1933.

Jean Rene. "Jouets Mexicains," *Comoedie*, Paris, August 7, 1930.

Regel, Luis Augusto, "Los Pintores de Aguascalientes," *El Universal Ilustrado*, Mexico City, November, 1929.

*Own Works:*

*Juguetes Mexicanos*. Edición G. F. L., Mexico, 1930.

*Calzado Mexicano Antiguo*. S. E. P., Mexico, 1930.

*15 Grabados en Madera*. Talleres R. del Cano, Madrid, 1930.

## FRANCISCO GOITIA

Brenner, Anita, *Idols Behind Altars*. Payson & Clarke, New York, 1929. pp. 234, 288–302.

Dwyer, Eileen, "The Mexican Modern Movement." *The Studio*, London, 1927. XCIV: 264–65.

Gamboa, Fernando, "Goitia Nuestro Pintor Ignorado," *El Nacional Revolucionario*, Mexico City, September, 1936.

Gamio, Manuel, *La Población del Valle de Teotihuacan*. S. E. P., Mexico, 1922.

## JESUS GUERRERO GALVAN

Acevedo Escobedo, Antonio, "La Pintura en la Secundaria Calles," *Revista de Revistas*, Mexico City, July, 1934.

Anonymous, "Imágenes J. G. G." *Universidad*, Mexico City, August, 1936.

Ibarra, Rosendo, "Siluetas Artísticas J. G. G.," *Thais*, Guadalajara, June, 1930.

Lira N., Miguel, "Nota sobre J. G. G.," *Excélsior*, Mexico City, October, 1931.

Urueta, Chano, "La Exposición de la Lear," *Todo*. Mexico City, July, 1936.

Zuno, Jose G., "J .G. G. y su Pintura," *Campo*, Guadalajara, January, 1925.

*Own Works:*

*Infancia*. (3 Litografías) Ediciones Arte Mexicano, Mexico City, 1936.

*Own Writings:*

"Los Nuevos Talleres de Artes Plásticas," *Izquierdas*. Mexico City, July, 1935. No. 51.

## MARIA IZQUIERDO

Anonymous, "Oleos de M. I." *Contemporáneos*, Mexico City, 1929. II: 16. pp. 103–106.

———"A Mexican Woman Painter." *New York World*. New York, November 23, 1930.

Cardoza y Aragon, Luis, "María Izquierdo," *El Nacional Revolucionario*, Mexico City, April 21, 1935.

Ictius, "M. I. y la Naturaleza Muerta," *El Universal*, Mexico City, September 7, 1930.

Islas Garcia, Luis, "Nuestros Jóvenes Pintores, M. I.," *Universal Gráfico*, Mexico City, October 13, 1929.

Mauret, Doctor, "La Pintura Mexicana Actual y M. I." *El Universal*, Mexico City, June 21, 1931.

Miguel, Francisco, "Pintores de Vanguardia. M. I." *El Universal*, Mexico City, October 14, 1930.

Rivera, Diego, "María Izquierdo," *El Universal*, Mexico City, October 6, 1929.

Villaurrutia, Javier, "María Izquierdo." *Mexican Folkways*, Mexico City, 1932. VII: 3.

## AGUSTIN LAZO

Anonymous, "Dibujos de Agustín Lazo," *Contemporáneos*, Mexico City, 1930. II: 23.

———"A. L." *Sur*, Buenos Aires, 1931. No. 2.

Cuesta, Jorge, "La Pintura de A. L." *Ulises*, Mexico City, 1927. I: 3.

Gorostiza, Celestino, "Agustín Lazo," *Revista de Revistas*, Mexico City, September, 1929.

Novo, Salvador, "Agustín Lazo," *El Universal Ilustrado*, Mexico City, 1929.

Villaurrutia, Javier, "Agustín Lazo," *Forma*. Mexico City, 1926. I: I.

———"Fichas sin Sobre para Lazo," *Contemporáneos*, Mexico City, July, 1928. I: 2.

———"Agustín Lazo," *G. de P. M. M.* Mexico City, 1934.

OWN WRITINGS:

"Pintura Infantil," *Mexican Folkways*. Mexico City, November, 1934.

BOOKS ILLUSTRATED:

Cardoza y Aragon, Luis, *Torre de Babel*. Editorial Avance, La Habana, 1930.

FERNANDO LEAL

Anonymous, "Grabados en Madera de F. L.," *Forma*, Mexico City, 1926. I: 3.

———"Un Fresco de F. L." *Eurindia*. Mexico City, 1936. I: I.

Gomez Maiellefert, E., "F. L." *L'Art Vivant*, Paris, 1930. VI: 122.

LEOPOLDO MENDEZ

Anonymous: "Leopoldo Méndez," *Bulletin of The Milwaukee Art Institute*. Milwaukee, 1933. VI: 7.

Plenn, Abel, "The Woodblocks of Leopoldo Méndez," *Mexican Life*, Mexico City, 1933.

Toor, Frances, "L. M." *Mexican Folkways*, Mexico City, 1932. VIII: 3–4.

BOOKS ILLUSTRATED:

Mar, Maria del, *La Corola Invertida*. Mexico, 1930.

Heine, Enrique, *Los Dioses en el Destierro*. Ampersam Press, Los Angeles, Calif. 1931.

Herrera Frimont, Celestino, *Los Corridos de la Revolución*. E. I. C. I. Pachuga, Hidalgo, 1934.

CARLOS MERIDA

Anonymous, C. M., *International Studio*. New York, January 1923.

———"C. M.," *Creative Art*. New York, April, 1930.

——"C. M.," *American Magazine of Art*. New York, January, 1931.

——"C. M.," *New York Times*. New York, April, 16, 1932.

——"C. M. Drawings," *New York Times*, New York, May 15, 1932.

——"C. M.," *Contemporáneos*, Mexico City, May, 1928.

——"Dibujos de Carlos Mérida," *Contemporáneos*, Mexico City, July-August, 1931.

BEALS, CARLETON, "The Art of a Guatemalan Painter," *Arts and Decoration*. New York, 1927.

BRENNER, ANITA, "A Painter from the Land of the Mayans," *International Studio*, New York, 1926.

CHARLOT, JEAN, "Carlos Mérida," *Contemporáneos*. Mexico City, 1928. I: 6.

CRESPO DE LA SERNA, JUAN, "El Pintor Carlos Mérida" *La Antorcha*, Mexico City, 1925. II: 3.

CUESTA, JORGE, *Carlos Mérida*, G. de P. M. M., Mexico City, 1934.

PARKER, HOWARD, "Las Nuevas Acuarelas de C. M.," *Mexican Folkways*, Mexico City, 1932. VII: 3.

*MONOGRAPH ON HIS WORK:*

*Carlos Mérida;* Preface by L. Cardoza y Aragón. Palacio de Bellas Artes, Mexico City, 1934.

*OWN WORKS:*

*Images de Guatemala;* Prologue by André Salmon. Editions Galleries Quatre Chemins, Paris, 1927.

*3 Motivos Huecograbados*. Ediciones Arte Mexicano. México. D. F., 1936.

*BOOKS ILLUSTRATED:*

BRENNER, ANITA, *Your Mexican Holiday*. G. P. Putnam's Sons, New York, 1935.

MAQUIAVELO, NICOLAS, *Rimas;* Preliminary Note by Agustín Velázquez Chávez. Ediciones Gamma, Tlaxcala, Tlax., 1936.

## ROBERTO MONTENEGRO

ANONYMOUS, "Frescos de Montenegro." *Contemporáneos*. Mexico City, 1931. IV: 38–39.

ESTRADA, GENARO, "20 Litografías de Taxco por R. M.," *Contemporáneos*. Mexico City, 1930. II: 24.

FERNANDEZ LEDESMA, GABRIEL, "El Pintor Roberto Montenegro," *Forma*. Mexico City, 1927. I: 7.

Villaurrutia, Xavier, "Montenegro Grabador en Madera," *La Antorcha*. Mexic City, 1925. ii: 2.

OWN WORKS:

*Veinte Dibujos;* Prologue by Henri de Régnier. Paris, 1905.

*Dibujos de Nijinsky.* London, 1906.

*Máscaras Mexicanas.* S. E. P., Mexico, 1925.

*Veinte Litografías de Taxco;* Preface by Genaro Estrada. Ediciones El Murcielag Mexico, 1930.

*Mexican Painting of the XIX Century.* S. E. P., Mexico, 1933, 1934.

BOOKS ILLUSTRATED:

*Clásicos Infantiles* (in collaboration with G. Fernández Ledesma). S. E. P., Mexic 1924.

Casasus de Sierra, Margarita, *33 de la U. F. F.* Editorial Cultura, Mexico, 1931.

Icaza, Xavier, *Trayectoria.* Universidad Obrera, Mexico, 1936.

## JOSE CLEMENTE OROZCO

Anonymous, "Orozco," *International Studio*. New York, March, 1924.

———"J. C. O." *The Arts*, New York, October, 1927.

———"J. C. O. Dibujos Oleos Frescos," *Contemporáneos*. Mexico City, 1929. ii: 1

———"Orozco," *Creative Art*, New York, September, 1931.

———"Orozco Completes New York Frescoes," *Art Digest*. New York, February 1931.

———"A Vast Fresco," *Art Digest*. New York, June, 1932.

———"Honor for Murals," *New York Times*. New York, February 17, 1934.

Brenner, Anita, "Murals with Meaning," *Creative Art*. New York, 1933. xii: pp. 134–36.

Charlot, Jean, "J. C. O. su Obra Monumental," *Forma*. Mexico City, 1927. i: 6.

Cuesta, Jorge, "J. C. O.," G. de P. M. M., Mexico City, 1933.

Goodrich, Lloyd, "The Murals of the New School," *The Arts*. New York, 193 xvii: 6.

Grafly, Dorothy, "Emotional Attitude versus Pictorial Aptitude," *Philadelph Public Ledger*. Philadelphia, February, 1929.

Hamblen, Emily, "Notes on Orozco's Murals," *Creative Art*. New York, 1929.

JEWELL, EDWARD ALDEN, "Orozco's Murals at Dartmouth," *Mexican Life*. Mexico City, 1934. X: 6.

MERIDA, CARLOS, "Decoración Mural de J. C. O. en la Casa, de los Azulejos," *Revista de Revistas*. Mexico City, 1923.

REED, ALMA, "Orozco and Mexican Painting," *Creative Art*. New York, 1931. IX: 3. pp. 198–207. *Idem, Mexican Life*. Mexico City, 1932. VIII: 3.

SCHMECKEBIER, LAWRENCE, "The Frescoes of Orozco," *Mexican Life*, Mexico City, 1933. IX: 3.

TABLADA, JOSE JUAN, J. C. O. The Mexican Goya. *International Studio*. New York, 1924.

TORO, OLIVERIO, "J. C. O. Gloria de la Pintura Contemporánea," *Excelsior*, Mexico City, July 19, 1934.

VALLE HELIODORO, RAFAEL, "J. C. O. Entrevista," *Revista de Revistas*. Mexico City, September, 1935.

*MONOGRAPHS ON HIS WORK:*

*J. C. O. As a Graphic Artist;* Introduction by Hans Tietze. Albertina Museum, Vienna, 1933.

*Orozco;* Introduction by Mrs. Alma Reed. Delphic Studios, New York, 1933.

*OWN WRITINGS:*

"New World, New Races and New Art," *Creative Art*. New York, 1929.

"Correction" *Mexican Folkways*. Mexico City, 1929. V: 1.

*Fresco Painting;* Preface. William Edwin Rudge, New York, 1933.

*Report of the Mexican Delegation*. First American Artists Congress, New York, 1936.

*BOOKS ILLUSTRATED:*

AZUELA, MARIANO, *The Underdogs*. Brentano's, New York, 1929.

SMITH, SUSAN, *Glories of Venus*. Harper Brothers, New York, 1931.

VELAZQUEZ ANDRADE, MANUEL, *Cuadros Vivos;* Preliminary Note by Agustín Velázquez Chávez. Ediciones Gamma, Tlaxcala, Tlax. 1936.

## CARLOS OROZCO ROMERO

ANONYMOUS, "Carlos Orozco Romero, Caricaturista," *Revista de Revistas*, Mexico City, January, 1929.

———"Cuadros de C. O. R.," *Contemporáneos*. Mexico City, 1929. II: 17.

Aragon Leyva, Agustin, "La Pintura Moderna en México," *Nuestra Ciudad*. Mexico City, 1929.

Brenner, Anita, "C. O. R. como Retratista," *Forma*. Mexico City, 1926. I: 3.

Espinoza, Celestino, "El II Salón de Otoño y C. O. R.," *El Día*. Madrid, 1929.

Rivas, Guillermo, "C. O. R., a Painter in Discord," *Mexican Life*. Mexico City, May, 1929.

——— "The Art of C. O. R.," *Mexican Life*. Mexico City, May, 1930.

Villaurrutia, Javier, *Carlos Orozco Romero*, G. de P. M. M. Mexico City, 1934.

Yanez, Agustin, "La Pintura en Jalisco y C. O. R.," *Bandera de Provincias*, Guadalajara, 1929.

Zuno, Jose G.,"Carlos Orozco Romero," *El Informador*, Guadalajara, 1918.

## MAXIMO PACHECO

Anonymous, "El Arte Moderno en las Américas," *Panamerican Union Bulletin*. Washington, D. C., March, 1935. pp. 277, 294.

——— "Note on Pacheco," *Creative Art*. New York, 1929.

Brenner, Anita, "M. P." *Idols Behind Altars*. Payson & Clarke, New York, 1929. pp. 238, 318–19.

Dwyer, Eileen, "The Mexican Modern Movement," *The Studio*. London, 1927. XCIV: 265.

Flyn Paine, Frances, "Murals by Pacheco," *Primitive Peasant Art*, New York, 1930. XXXII: 6.

Lazo, Agustin, "Máximo Pacheco," *Forma*. Mexico City, 1926. I: 2.

Toor, Frances, "M. P.," *Mexican Folkways*. Mexico City, 1927. III: 3.

——— "Los Frescos de Pacheco en la Escuela Sarmiento," *Mexican Folkways*. Mexico City, 1927. III: 3.

## JOSE GUADALUPE POSADA

Anonymous, "J. G. P.," *Mexican Folkways*. Mexico City, 1928. IV: 3.

Atl, Doctor, *Las Artes Populares en México*. Editorial Cultura, Mexico City, 1922. Chapter XXIII, pp. 131–96.

Brenner, Anita, "A Mexican Prophet," *The Arts*. New York, 1928. XIV: 1.

——— "Posada the Prophet," *Idols Behind Altars*. Payson & Clarke, New York, 1929. pp. 184–198.

CHARLOT, JEAN, "Un Precursor del Movimiento de Arte Mexicano," *Revista de Revistas*. Mexico City, August, 1925.

*MONOGRAPH ON HIS WORK:*

José Guadalupe Posada; Introduction by Diego Rivera. *Mexican Folkways*, Mexico City, 1930.

## FERMIN REVUELTAS

ANONYMOUS, "El Pintor Fermín Revueltas," *Revista de Revistas*. Mexico City, August, 1935.

BRENNER, ANITA, "F. R." *Idols Behind Altars*. Payson & Clarke, New York, 1929. pp. 238, 246, 258.

MERIDA, CARLOS, "Fermín Revueltas," *G. de P. M. M.*, Mexico City, 1934.

MOLINA ENRIQUEZ, RENATO, "La Pintura Mural de F. R.," *Forma*. Mexico City, 1927. I: 3.

PLENN, ABEL, "Fermín Revueltas," *Mexican Life*. Mexico City, 1934. X: 3.

VELAZQUEZ CHAVEZ, AGUSTIN, "Fermín Revueltas," *Avante*. Mexico City, August, 1935.

## DIEGO RIVERA

ANONYMOUS, "Diego Rivera," *International Studio*. New York, February-March, 1924.

———"Murals at Cuernavaca Government Palace," *Mexican Folkways*, Mexico City, 1930. VI: 4.

———"Diego Rivera," *Creative Art*. New York, May, 1931.

———"History of Mexico," *New York Times*. New York, November 1, 1931.

———"Diego Rivera," *Creative Art*. New York, January, 1932.

———"Detroit in Furor over Rivera Art," *New York Times*. New York, March 22, 1932.

———"Diego Rivera," *Creative Art*. New York, April, 1933.

———"Rockefeller versus Rivera," *Time*. New York, May 22, 1933.

———"The Rivera Case," *Art News*. New York, 1933. XXI: 34.

———"Un Pintor Mexicano, Diego Rivera," *Havana*. Habana, April 19, 1914. p. 188.

BARR, ALFRED H., JR., *A brief Survey of Modern Painting*. Museum of Modern Art, New York, 1934. pp. 18, 22.

Bulliet, C. J., *The Significant Moderns and Their Pictures*. Covici, Friede, New York, 1936. pp. 156–58, 220.

Dayton, Dorothy, "Rivera," *New York Sun*. New York, November 17, 1931.

Evans, Ernestine, "Diego Rivera," *Art Work*. London, 1927.

Garcia Maroto, Gabriel, "La Obra de Diego Rivera," *Contemporáneos*. Mexico City, 1928. I: 1.

Gavreau, Emile, *What So Proudly We Hailed*. Macaulay Co., New York, 193 p. 198.

Gomez de la Serna, Ramon, "Riverismo," *Sur*, Buenos Aires, 1931.

Gomez Morin, Manuel, "Los Frescos de Diego Rivera," *La Antorcha*, Mexico City 1925. I: 20.

Leighton, Frederic, "Rivera's Mural Painting," *International Studio*. New York 1924.

Lewinsohn, S. A., "Mexican Murals and Diego Rivera," *Parnassus*. New York December, 1935.

Martin, Rosa Lee, "Rivera Mural Exiled From Radio City, Enshrined in Mexico. *New York Times*. New York, September 22, 1935.

Montenegro, Manuel, "Qué importancia tiene la obra de Diego Rivera?" *L Antorcha*. Mexico City, 1924. I: 7.

Pach, Walter, "The Revolution in Painting: the Evolution of Diego Rivera, *Creative Art*. New York, 1929.

Parker, Howard, "The New Rivera," *Mexican Folkways*, Mexico City, 1932. VII: 

Putzel, Howard, "The Work of Diego Rivera," *American Magazine of Art*. New York, 1928.

Tablada, Jose Juan, "Diego Rivera, Mexican Painter," *The Arts*. New York, 192

Villaurrutia, Javier, "Historia de Diego Rivera," *Forma*. Mexico City, 1927. I: 

*MONOGRAPHS ON HIS WORK:*

*Das Werk des Malers Diego Rivera*. Berlin, 1928.

*The Frescoes of Diego Rivera;* Introduction by Ernestine Evans. Harcourt Brace New York, 1929.

*Frescoes by Diego Rivera in Cuernavaca;* Text by Emily Edwards. Mexico City 1932.

*Portrait of America;* Text by Bertram C. Wolfe. Covici, Friede, New York, 1934.

*Diego Rivera Portfolio*. The Museum of Modern Art, New York, 1934.

*Diego Rivera*, Samuel Ramos. Imprenta Mundial, Mexico City, 1935.

ortrait of Mexico; Text by Bertram C. Wolfe. Covici, Friede, New York, 1937.

OWN WRITINGS:

From a Mexican Painter's Notebook." *The Arts*, New York, 1925.

Autobiografía." *El Arquitecto*, Mexico City, April, 1926.

Pintura de Pulquerías." *Mexican Folkways*, Mexico City, 1926. Vol. II. N. 2.

El Caso del Centro Rockefeller." *Revista de Revistas*, Mexico City, July, 1933.

What is Art For." *Modern Monthly*, New York, August, 1934.

BOOKS ILLUSTRATED:

RIVAS, *Cuauhtemoc*. Mexico, D. F., 1925.

VELAZQUEZ ANDRADE, MANUEL, *Fermin Lée*. Textos Modernos, Mexico City, 1927.

GOLDSCHMIDT, ALFONS, Mexiko. Ernst Rowholt Verlag, Berlin.

BEALS, CARLETON, *Mexican Maze*. Lippincott, Philadelphia, 1933.

CHASE, STUART, *Mexico*. Macmillan Co., New York, 1935.

MANUEL RODRIGUEZ LOZANO

ANONYMOUS, "Manuel Rodríguez Lozano," *Forma*. Mexico City, 1927. I: 4.

——"Dibujos de Rodríguez Lozano," *Contemporáneos*. Mexico City, 1931. III: 35.

ALTOLAGUIRRE, MANUEL, "Belleza Cóncava," *Contemporáneos*, Mexico City, 1931. III: 35.

ICTIUS, "Manuel Rodríguez Lozano," *El Universal*. Mexico City, October, 1930.

PACHECO, LEON, "La Pintura de Rodríguez Lozano," *Contemporaneos*. Mexico City, 1929. I: 11.

VILLAREAL, ENRIQUE, "The Aesthetics of Rodríguez Lozano," *Mexican Life*. Mexico City, 1932. VIII: 6.

BOOKS ILLUSTRATED:

HENESTROSA, ANDRES, *Los Hombres que dispersó la Danza*. Editora Aguilas, Mexico City, 1930.

REYES, ALFONSO, *El Testimonio de Juan Peña*. Río de Janeiro, 1930.

ALBERTI, RAFAEL, *Verte y no Verte*. Edición Fábula, Mexico City, 1935.

## ANTONIO RUIZ

Anonymous, "Los Dibujos del Pintor Antonio Ruíz," *Forma*. Mexico City, 1927. I: 4.

——— "Modern Painters of Mexico," *New York Herald*. New York, January, 1928.

Fernandez Ledesma, Enrique, "El Pintor Antonio Ruíz,"*El Universal*. Mexico City, August, 1930.

Figueroa, Jose Luis, "El Teatro de los Niños," *El Nacional Revolucionario*. Mexico City, September, 1931.

## DAVID ALFARO SIQUEIROS

Anonymous: *Síntesis de las Opiniones emitidoas sobre la Obra de Siqueiros*. Mexico City, February, 1932.

——— "La Pintura en el xxiii Salon de Arte," *Crítica*. Buenos Aires, September, 1933.

——— "White Walls and a Fresco in California," *Arts and Decoration*. New York 1934. XLI: 2.

Brenner, Anita, "Un Verdadero Rebelde en Arte," *Forma*. Mexico City, 1926. I: 2.

——— "David Alfaro Siqueiros," *Idols Behind Altars*. Payson & Clarke, New York. 1929. pp. 260–67.

——— "A New World Is Opened to the Artist," *New York Times Magazine*. New York, April 28, 1935.

Brumen, Blanca Luz, "David Alfaro Siqueiros y su Revolucionaria Pistola de Aire," *Repertorio Americano*. San Jose, Costa Rica, 1932. XXV: 12.

Gorostiza, Jose, *David Alfaro Siqueiros*, G. de P. M. M., Mexico City, 1933.

Guido, Angel, "David Alfaro Siqueiros, un Gran Pintor Mexicano," *La Prensa*. Buenos Aires, March 26, 1933.

Wiegand, Von Charmiond, "David Alfaro Siqueiros," *New Masses*. New York, May 1, 1934.

Ortega, "Alfaro Siqueiros habla sobre la Pintura Mexicana," *Jueves de Excelsior*. Mexico City, July 18, 1934.

*Own Works:*

*13 Grabados en Madera*. Preface by W. Spratling. Taxco, Guerrero, 1931.

*Own Writings:*

"Manifiesto a los Pintores de América," *Vida Americana*. Madrid, 1922. I: 1.

"Un Llamamiento a los Pláticos Argentinos," *Crítica*. Buenos Aires, September, 1933.

"Manifiesto a los Plásticos Uruguayos," *El Día*. Montevideo, October, 1933.

*Ejercicio Plástico.* Buenos Aires, December, 1933.

"Errores Técnicos y Políticos del Movimiento Pictórico Mexicano." *El Universal Ilustrado.* Mexico City, August, 1934.

*The Mexican Experience in Art.* First American Artists Congress, New York, 1936.

## RUFINO TAMAYO

Anonymous, "El Pintor Rufino Tamayo," *El Universal.* Mexico City, August 2, 1925.

——— "Acuarelas y Oleos de Rufino Tamayo," *Contemporáneos*. Mexico City, 1928. I: 4.

Breuning, Margaret, "Mexican Painter in Work Reveals the Truly Primitive," *New York Times.* New York, October 23, 1926.

Crowninshield, Frank, "Tamayo," *Ulises*, Mexico City, 1930. I: 3.

Fernandez Ledesma, Gabriel, "El Pintor Rufino Tamayo," *Forma*. Mexico City, 1929. I: 5.

Garza, Macedonio, 'Rufino Tamayo," *Revista de Revistas*, Mexico City, February, 1929.

Gorostiza, Celestino, *Rufino Tamayo*, G. de P. M. M., Mexico City, 1933.

Miguel, Francisco, "Rufino Tamayo," *Catálogo de la Galería de Arte Moderno.* Mexico City, 1929.

Montano, Jorge, "Tamayo, Leader of a New Mexican Painting," *Mexican Life,* Mexico City, November, 1929.

Owen, Gilberto, "La Exposición Tamayo," *Revista América*. Mexico City, 1926. I: 4, 5.

Parker, Howard, "Rufino Tamayo," *Mexican Folkways*. Mexico City, 1932. VII: 3.

*MONOGRAPH ON HIS WORK:*

*Rufino Tamayo;* Preface by L. Cardoza y Aragón. Publicaciones del Palacio de Bellas Artes, Mexico City, 1934.

## ALFREDO ZALCE

ANONYMOUS: "Litografías de Alfredo Zalce," *Contemporáneos*, Mexico City, 1931. III: 39.

——— "Notes on Alfredo Zalce," *Italian Court*. Chicago, 1934.

BRACHO, JESUS, *La Exposición en la Galería Posada*. Mexico City, 1932.

VILLAURRUTIA, JAVIER, "Alfredo Zalce,"*Contemporáneos*, Mexico City, 1931. III: 36.